IMAGES
of America

DOWNTOWN
EVERETT

Mike,
Happy 57th
May we celebrate many more

Love you

Pat & Dan

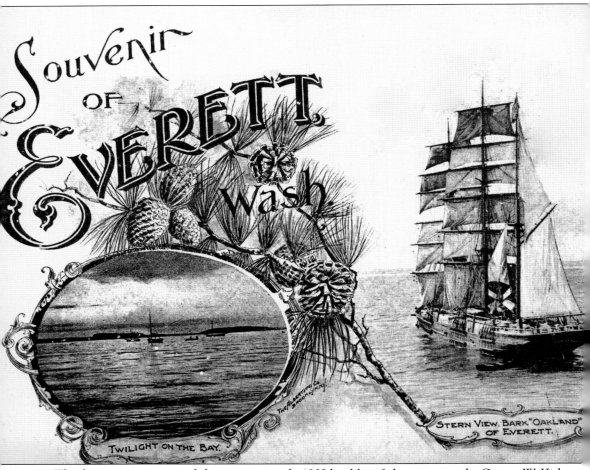

Souvenir of Everett, Wash.

The Albertype Co. Brooklyn N.Y.

TWILIGHT ON THE BAY.

STERN VIEW, BARK "OAKLAND" OF EVERETT.

This line engraving graced the cover page of a 1902 booklet of photogravures by George W. Kirk and Loren H. Seely. Kirk Studios was one of a series of photographic studios housed in the Realty Building on the northeast corner of Hewitt and Colby. Much of Everett's rich photographic history is now archived in the Everett Public Library's Northwest Room.

ON THE COVER: This *c.* 1900 photograph, depicting the mills and shipyards of Everett's Port Gardner Bay, bears the title "Pittsburgh of the West."

IMAGES
of America

DOWNTOWN
EVERETT

M. L. Dehm

ARCADIA
PUBLISHING

Published by Arcadia Publishing
Charleston, South Carolina

Printed in the United States of America

Library of Congress Catalog Card Number: 2005933803

For all general information contact Arcadia Publishing at:
Telephone 843-853-2070
Fax 843-853-0044
E-mail sales@arcadiapublishing.com
For customer service and orders:
Toll-Free 1-888-313-2665

Visit us on the Internet at www.arcadiapublishing.com

CONTENTS

ACKNOWLEDGMENTS

The images in this book appear courtesy of the Everett Public Library except for the 2005 photographs in chapter 6, which are provided by the author.

The author would like to thank the Everett Public Library and the people and organizations that donated the photographs to the library's collection. These include the Everett Community College, the Snohomish County Museum, and numerous private donors.

The author would especially like to thank Margaret Riddle of the Everett Public Library's Northwest Room for her tireless work towards this project. Thanks also go out to Myrle P. Dehm for his information on logging and the pulp and paper industries.

INTRODUCTION

It was spring of 1792 when Capt. George Vancouver first looked on the land that we know today as Everett. Striding along the deck of the famed sloop *Discovery*, Vancouver commented on the serene climate, the pleasing landscapes, and the apparent fertility of the region. He took a deep lungful of fresh air, fired his cannons, and promptly left. It was the most exciting thing that would happen to the area for nearly a century.

It was the late 1800s before white settlers came to build a town. Even then, it wasn't the mild climate or the beauty that drew them. It was financial speculation, pure and simple. They were attracted by the lush forested peninsula with its deepwater port, a seemingly endless supply of timber, and a nearby mine. The area's Native American population had been forced to relocate following the Indian Wars of the 1850s. Vast tracts of land around Port Gardner Bay were uninhabited and waiting to be developed.

This fact was not lost on a minor timber baron named Henry Hewitt Jr., who, in 1888, had come to survey the region's resources. He immediately began investing and soon struck up a partnership with Charles Colby. Colby was a New York banker, a Northern Pacific Railroad board member, and, like Hewitt, a capitalist eager for wealth and power.

Both men knew that James J. Hill was due to extend the Great Northern Railroad to the west coast. If the western terminus ended up at Port Gardner Bay, serious money could be made by those who controlled the land surrounding it. Hewitt's plan was to court Hill by building a city worthy of becoming the Great Northern's final stop. One night at dinner, the ever-glib Hewitt proposed that this town should be named after Colby's young son Everett. The suggestion was accepted, and the historic Everett Land Company was born.

Impressed by Hewitt and his visions of metropolitan grandeur, Colby returned to New York and began gathering other investors for their enterprise. Recruitment went well. Fellow Northern Pacific board member Colgate Hoyt was soon persuaded to join them. Capitalist Charles Wetmore was convinced to open a shipyard for whaleback cargo ships in the new town. Colby and Hoyt arranged with friends and acquaintances for a paper mill and a nail factory to be built.

Meanwhile Hewitt had been busy. He struck a deal with his investment competitors, the Rucker brothers, in order to retain control of the proposed city site. He also sent an engineer to assay the mining area east of the town. Initial reports came back glowing with promise. This information was prematurely and probably deliberately leaked to the New York crew.

It was then that Colby acquired the jewel in the Everett Land Company's corporate crown. John D. Rockefeller was an acquaintance of Colby and Hoyt who attended the same church and ran in the same New York social circles. Having money to spare, the famed millionaire agreed to invest in the venture. The result was electric. Rockefeller's name gave sudden credibility to Hewitt's lofty visions. Soon everyone was jumping on the Everett bandwagon—everyone, that is, except James J. Hill.

Hill refused to commit himself to a single terminus for the Great Northern line. His caution stood him well. The financial panic of 1893 hit before Hill made up his mind. Several large

railroads went into receivership, but Hill's Great Northern remained solvent and eventually swallowed up the struggling Northern Pacific that Colby and Hoyt were connected to. The price of timber plummeted. Wages were cut. Three of Everett's five banks closed. The mine reported disappointing returns and investors fled.

Rockefeller was not amused. Rather than besmirch his financial reputation, he proceeded to take control of the Everett Land Company. Hewitt was quietly replaced. Colby and Hoyt soon followed. The company's assets were liquidated in such a manner that Rockefeller's other investments benefited, cutting the millionaire's losses. Others were not so lucky.

It was from this atmosphere of depression and financial ruin that the city of Everett really emerged. The dream of a "Pittsburgh of the West" was replaced by the reality of a struggling mill town that was determined to make the best of what fate had handed it. The hard-working residents continued to build Hewitt's city, but it wasn't as grand as investors had hoped. More challenges would come further down the line. But the city survived and grew.

Today Everett is still sustained by an industrial base. Aerospace and technical jobs replaced lumber and shipbuilding professions. A naval base now operates where Wetmore's whaleback vessels once sailed. There are museums, galleries, and a performing arts center. Everett has its own baseball team, and the street that bears Hewitt's name now hosts a huge events center with a resident hockey team. It took a lot longer than he had planned, but Hewitt's dream of a great city eventually became a reality.

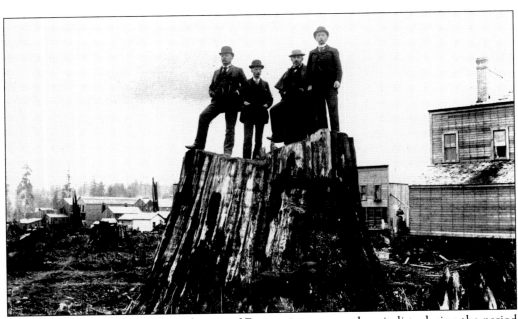

Everett owes its start to the speculations of Eastern investors and capitalists during the period following the Civil War. Investor John McManus, dapper in his duster coat, is second from the right in this photograph from May 1892. The stump was located on what was soon to become Everett Avenue. Senator McManus had ties to the Bank of Everett and the Mitchell Land Company. His own residence, designed by F. A. Sexton, stood at 2528 East Grand Avenue. The others pictured here are unidentified, but the second man from the left may be R. M. Mitchell.

One

SETTING THE STAGE

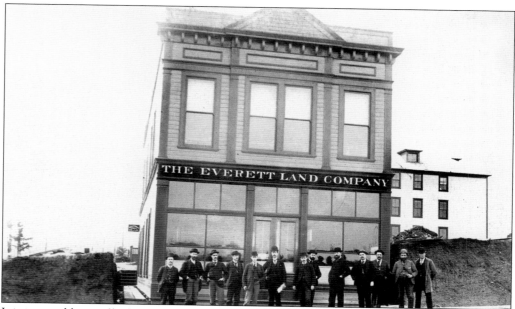

It is impossible to talk about the birth of Everett without starting at the Everett Land Company. Wealthy investors from the East, led by Henry Hewitt and Charles Colby, came to Port Gardner Bay to build a city. A lot of money changed hands in the office that stood at the corner of Pacific Avenue and Oakes. You won't find John D. Rockefeller in this 1892 photograph, though. He never actually came to see the town he invested in.

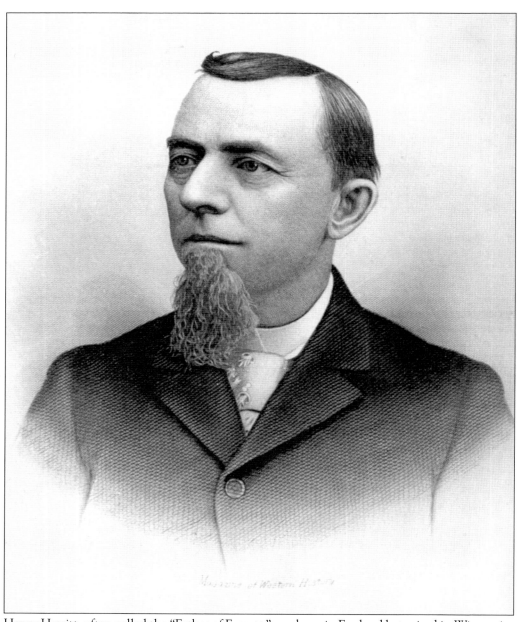

Henry Hewitt, often called the "Father of Everett," was born in England but raised in Wisconsin. The son of a minor timber baron, Hewitt grew up in the family business. He was scouting the timber resources of the Pacific Northwest when he happened upon Port Gardner Bay and saw an ideal investment opportunity. There were many natural resources just waiting to be harvested. The harbor was suitable for shipping, and if James J. Hill brought the Great Northern Railroad into Everett, land prices in the city would soar. Hewitt had visions of a booming industrial metropolis. He hoped to make Everett the "Pittsburgh of the West" and make himself all the richer in the bargain. It didn't quite turn out that way. The financial panic of 1893 came to Everett before the railroad did, and Hewitt found himself overextended. John D. Rockefeller bought out Hewitt, and the "Father of Everett" slunk off into obscurity.

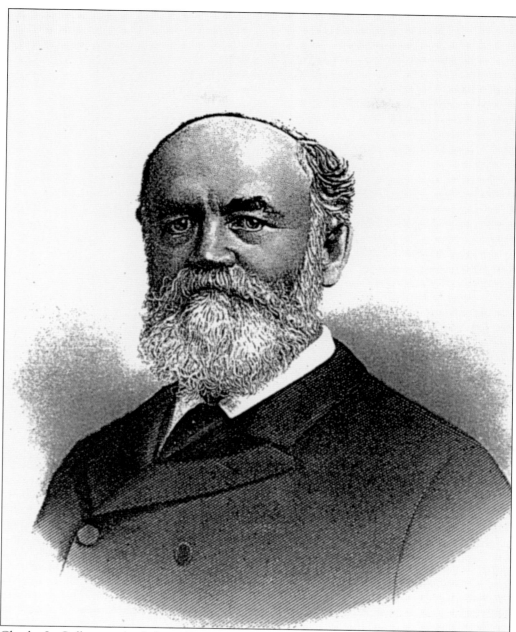

Charles L. Colby was the father of Everett in a literal sense. The city was named after his son. One night at dinner, so the story goes, Colby's young son Everett was demanding more dessert. Hewitt, who was a dinner guest, supposedly quipped, "We should name our city Everett. This boy wants only the best and so do we." There is little doubt that naming the city after the boy cemented the friendship between Colby and Hewitt. Charles Colby was a New York banker who sat on the board of the Northern Pacific Railroad and was president of the American Steel Barge Company. It was his connections with John D. Rockefeller that brought money and prestige to the fledgling Everett Land Company.

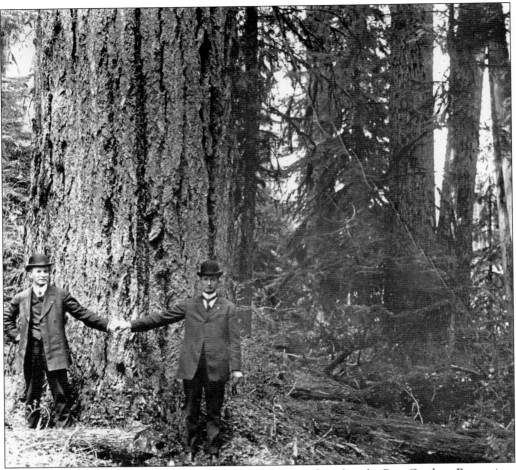

Here the Rucker brothers demonstrate the size of the trees found in the Port Gardner Bay region. Wyatt and Bethel Rucker hailed from Ohio and were Hewitt's rivals. They too hoped to build a city and had bought up as much of the land as they could in order to do it. Hewitt had to cut a deal with the Ruckers in order to try and retain control of the proposed town. The brothers agreed to sell many of their holdings to the Everett Land Company, but retained strategic lots. These soon skyrocketed in value. The Rucker investments paid off handsomely for the pair. Many things in Everett now bear the Rucker family name including a park and a major thoroughfare. But none is perhaps quite as famous as the 46-foot high, pyramid-shaped Rucker family tomb at the Evergreen Cemetery. The Rucker Mansion still stands at 412 Laurel Drive. It was built in 1905 and was the residence of Bethel Rucker and his family for only a short time.

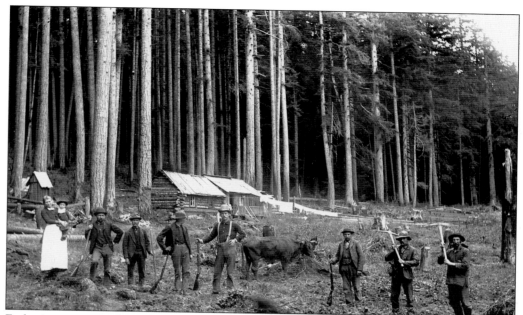

Early pioneers in Snohomish County literally cut their homesteads out of the woods. Trees had to be felled and the stumps pulled in order to form arable land. Even then the soil was too acidic to grow most crops. There were no roads. The trails that led from place to place were simply muddy paths lined with brush piles of clearing debris.

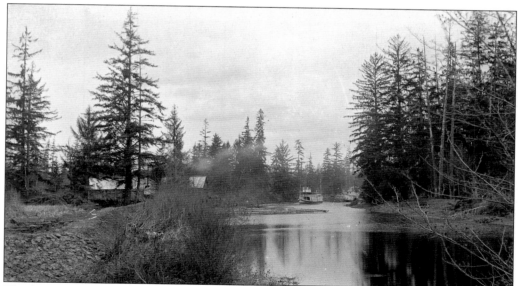

The fastest way to get from Seattle to Everett was using the "mosquito fleet." These speedy little steam ships buzzed from port to port ferrying people and goods around the region. In later years, the mosquito fleet was replaced by Washington State Ferry system, but the mystique lingers on. The name is now used by a local tour boat company. This 1892 photograph was taken on the Snohomish River.

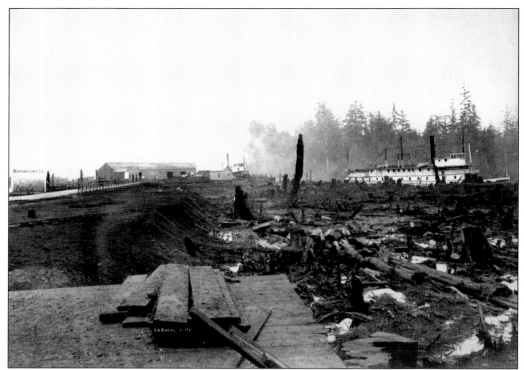

When the building boom began in the early 1890s, newcomers found few places to stay. For those who did not care to rough it under canvas, some of the steamships were converted into floating hotels, as seen in this January 1892 photograph. The ship is believed to be the *Skagit Chief.*

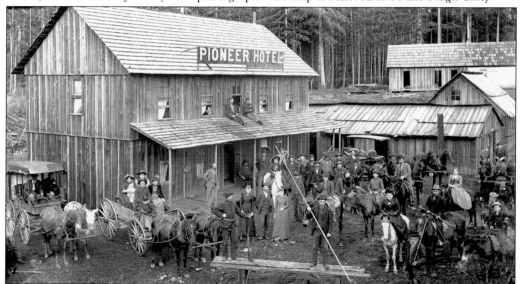

Hotels soon were built. This photograph of pioneers staying at the appropriately named Pioneer Hotel was taken in 1892. By this time, word had spread that millionaire John D. Rockefeller had invested in the new city of Everett. People believed that any project Rockefeller was involved in must be a sure bet. For many, it was a gamble that would lead to ruin.

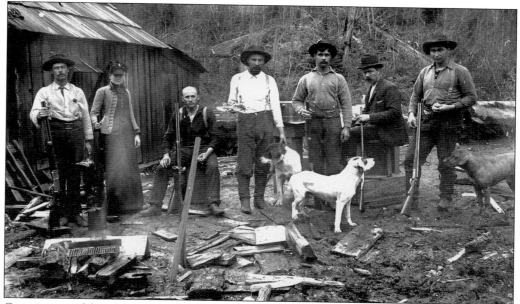

Construction debris litters the yard of this 1892 dwelling. They seem to be enjoying a meal and, judging from the pristine state of their shoes and clothes, are dressed in their best, despite the mud. The photograph was taken by the studio of R. King and D. W. Baskerville.

In 1892, King and Baskerville Studios took this photograph of the Rosedale School. It would be the archetype of a one-room schoolhouse except for the logging debris surrounding it. There is little doubt what these children's families did for a living. The teacher is standing to the far left.

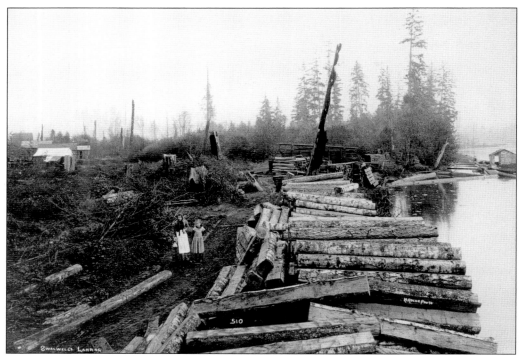

In October 1891, a mother and daughter stand at Swalwell's Landing on the west bank of the Snohomish River. The river was of major importance to the local residents. It was a way to travel as well as a way to move the timber products that were being produced as the land was cleared.

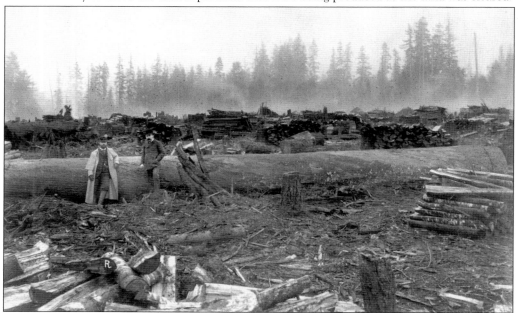

Many of the financiers and capitalists that invested in Everett never left their comfortable homes in the East. But others came to the new city to watch the progress of their investment. This photograph looks south from what is now the intersection of Pine Street and Pacific Avenue.

16

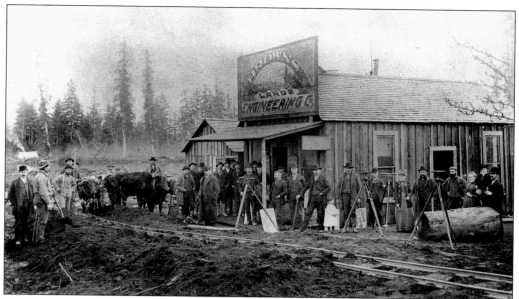

Brown Land and Engineering Company was one of the first companies to help break ground during the Everett boom. This February 1892 photograph is a reminder of the rough conditions that met the early developers and of the primitive equipment that was available for land clearing and grading. Here a team of oxen are being used.

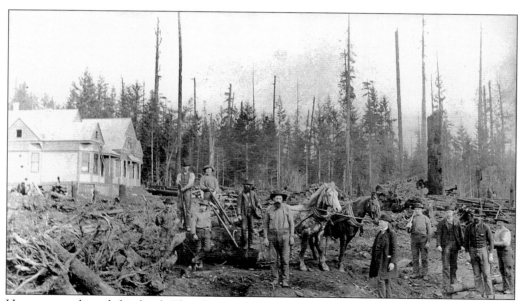

Horsepower cleared this land. The photograph was taken from what would eventually become the intersection of California Street and Everett Avenue. All of the stumps had to be removed in order for the land to be properly graded. To the far left are the Swalwell Cottages.

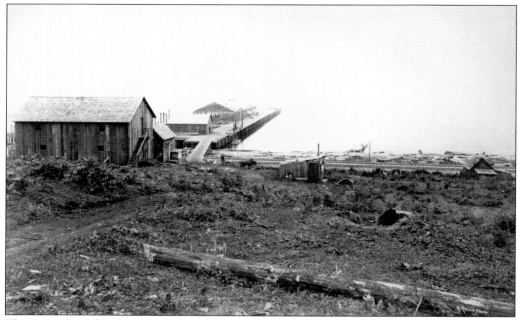

The Puget Sound Wire Nail and Steel Company was the brainchild of Alfred Rutgers Whitney. As president of the Brooklyn Wire Nail Company, Whitney knew that the building boom of Everett would guarantee a good market for his products. These could be made easier and cheaper on site. Photographer Frank LaRoche was hired in 1891 to record the building and operation of the model factory.

On March 7, 1890, the Seattle Montana Railroad was incorporated. The line ran right past the Puget Sound Wire Nail and Steel Company on Port Gardner Bay, running passengers and goods through Everett soon after LaRoche took this picture in 1891.

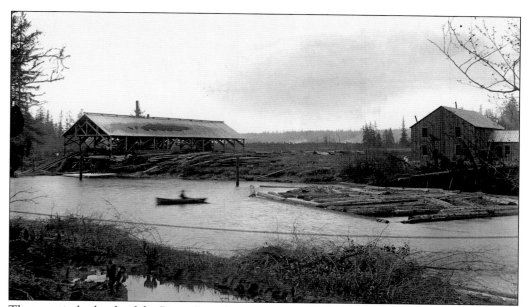

The vast timberlands of the Puget Sound were tempting to Easterners who had already depleted their own forests. It was the lure of timber that first drew Henry Hewitt to the area, and it was the same that would add significantly to the Weyerhaeuser coffers. This unidentified sawmill sits on the Snohomish River.

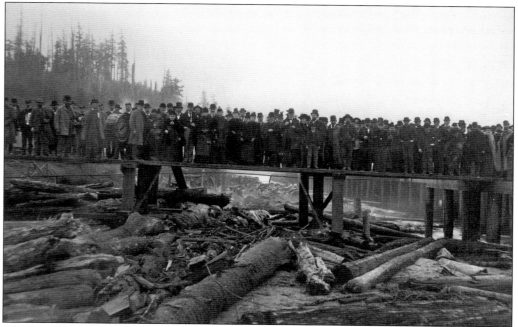

Charles Wetmore's contribution to the city of Everett was to invest in a shipyard to produce whaleback ships. In December 1891, the citizens of Everett, along with a band, welcomed the first whaleback ship into the harbor. The boat bearing Wetmore's name carried supplies to build other ships. It had come around Cape Horn and was three weeks late due to bad weather and mechanical difficulties.

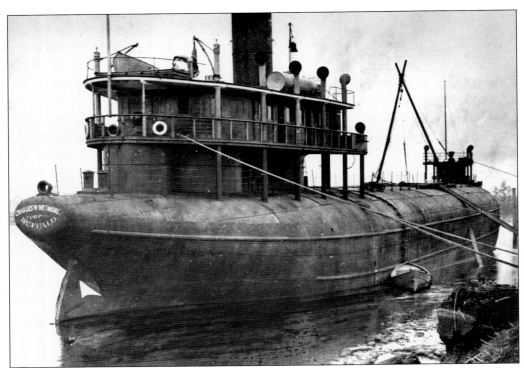

Whaleback ships had a unique design and were said to be very stable in the water. The low hull was ideal for hauling freight, but the rounded edges meant that its deck was often awash. Despite the odd appearance, the vessels were a boon for the American Steel Barge Company. Alexander McDougall, the ships' designer, was a friend of Charles Colby and John D. Rockefeller.

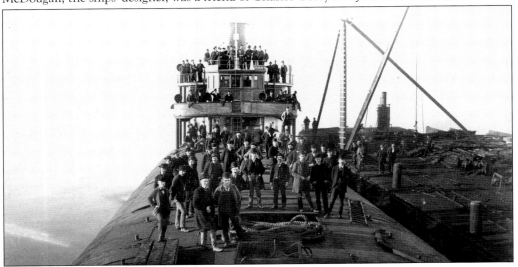

This closer view of the *Wetmore* gives a better idea of the ship's scale. The barge works in Everett would never run at full capacity. Eventually the company produced only one whaleback ship: the *City of Everett*. The *Wetmore* was fated to run aground in Coos Bay, Oregon, on its return journey to the east. The *City of Everett* had an illustrious career, but was eventually lost in the Caribbean.

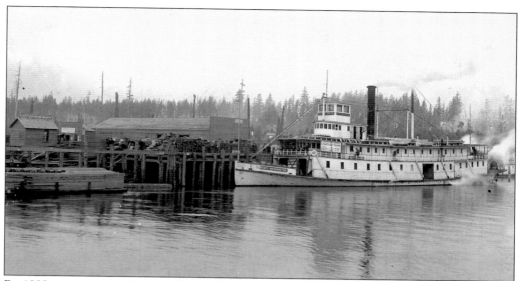

By 1892, steamers, such as the *State of Washington*, began bringing more and more people into Everett. The sign on its side advertises the prices of its popular Seattle-to-Tacoma run. Building lots were hard to come by for the average person. Most of the land was being hotly traded between speculators.

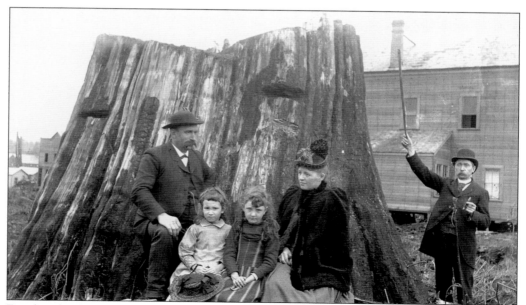

Families that had money were in a far different situation than those who were sleeping in canvas tents or bunking in converted steamships. They would have stayed in one of the newer hotels that had been built in the region. The well-to-do were able to pay the steep prices that land speculators were charging in order to build their home.

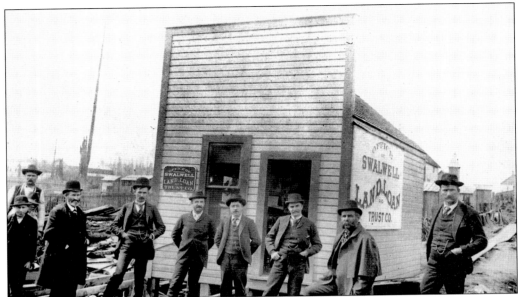

Those looking to buy land might visit the Swalwell Land Loan and Trust on Chestnut Street, just south of Hewitt Avenue. The Swalwell family consisted of several brothers who were friends with the Rucker brothers. The eldest brother, W. G. Swalwell, was president of Swalwell Land Loan and Trust Company, owner of the First National Bank of Everett, and president of the Mitchell Land and Improvement Company among others.

The extended Swalwell family all lived on Pine Street in Everett. Here they pose on April 13, 1892, in front of one of the houses. The first of the Swalwell residences were a pair of cottages at 2714 Pine Street. They were designed in 1891 by architect F. A. Sexton. Another house was built for W. G. Swalwell at 2730 Pine Street. It was completed in May 1892.

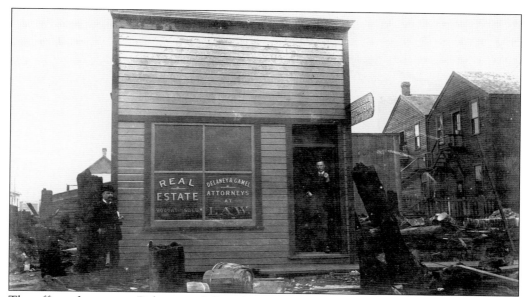

The office of attorneys Delaney and Gamel sits among the new construction debris in March 1892. Besides practicing law, the two men also speculated in real estate. This was just one of many offices offering real estate services to the newcomers of Everett. The market was so hot that prices on a lot could soar overnight, and many lots changed hands several times without ever having been developed.

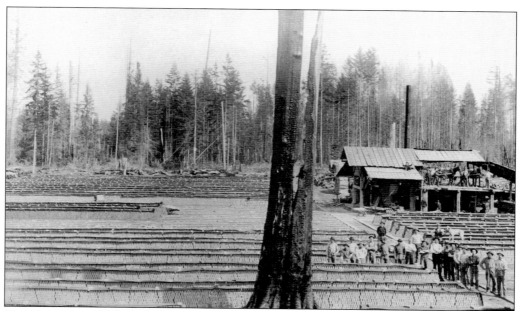

The Sherman and Wasson Brickyard, seen here in 1892, was hard-pressed to meet the demand of the booming city. The bricks that they produced can still be seen in many of the preserved downtown area structures. The Bast Brickyard, located on the Snohomish River, also operated at this time.

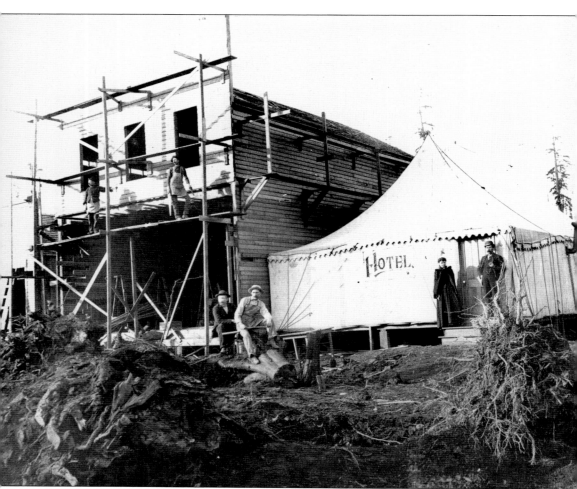

Many early businesses started out under canvas. Here a tent hotel operates next to the construction of the future Gem Saloon. This site is near what would eventually become the intersection of Hewitt Avenue and Chestnut Street. The Gem would have the honor of being Everett's first, but certainly not last, saloon.

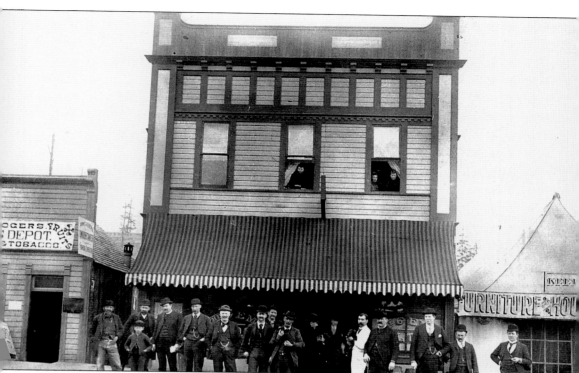

Here is the completed Gem Saloon in early 1892. Ladies peek coyly from the upstairs windows. The tent hotel next door has become a furniture shop. On the other side is Rogers News Depot, which also housed the local undertaker. It is said that John T. Rogers sometimes rented coffins as beds when the town's hotels were full.

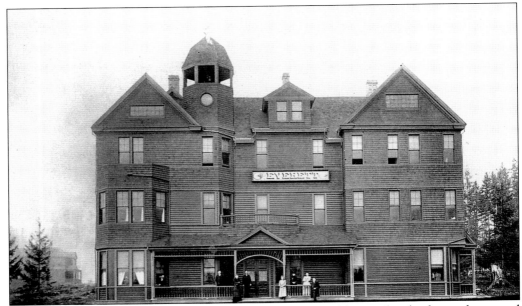

The Everett Hotel was one of several impressive structures quickly completed to house the genteel newcomers. The wooden structure stood, appropriately enough, on Everett Avenue. This March 29, 1892, photograph was taken by King and Baskerville Studios.

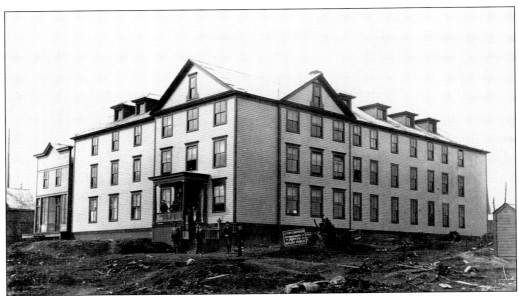

Perhaps not quite as majestic, the Summit Hotel stood on Oakes Avenue near Pacific Avenue. Construction is obviously still going on inside of the building judging by the ladder standing at the entrance door. A sign outside advertises the notary and investment services of J. T. McCarther. This photograph is from March 1892.

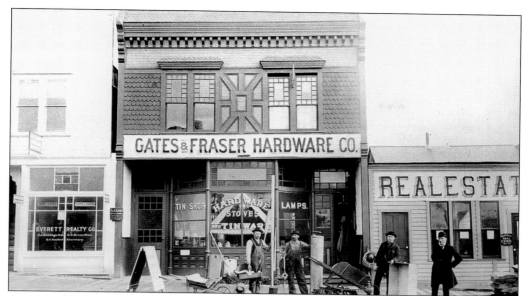

An example of just how wild the building boom was is evidenced by this April 30, 1892, photograph of the Gates and Fraser Hardware store, flanked by two real estate offices. Here men stand with some of the items that could be purchased in a store like Gates and Fraser. The store stood on Hewitt Avenue near Chestnut Street.

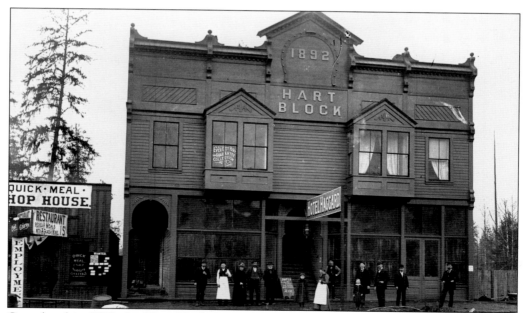

Completed in 1892, the Hart Block featured a hotel as well as other businesses. An earlier photograph shows the downstairs occupied by a company selling window glass and paint. In this photograph, taken later that same year, the window glass operation is gone and the hotel is open. A collection agency operates upstairs and a small chophouse offers wine and oysters next door.

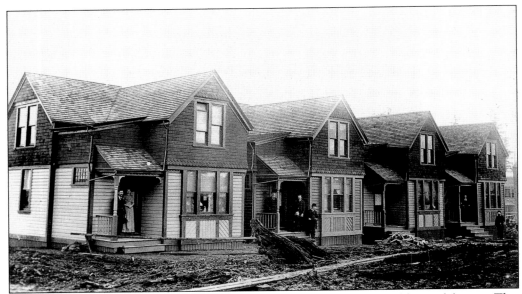

Eventually private residences began to emerge among the commercial buildings of the city. This is a view of Chestnut Street between Hewitt and California Avenues. Despite the mud in the yard, there are lace curtains at the windows in this March 1892 photograph.

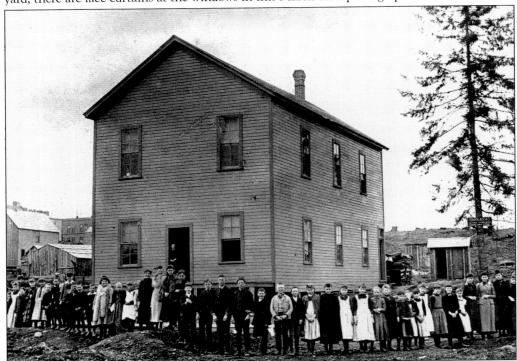

Quickly following the construction of houses, schools for the children were built. The Broadway School was located on Broadway Avenue just south of Hewitt Avenue. Some of the children in this 1892 photograph are wearing simple clothes and aprons while others, such as the tall girl and boy to the left, appear to be dressed in finery.

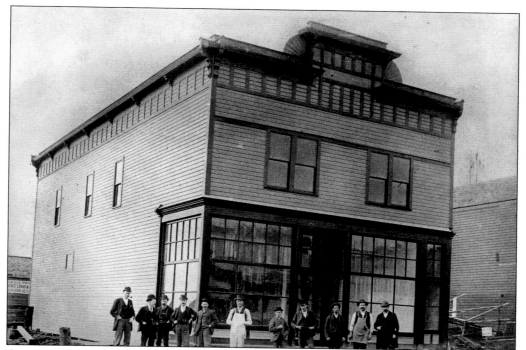

Once a newcomer to Everett had built their home, they needed to furnish it. The building in this May 1892 photograph is Barron's Furniture store near Hewitt Avenue and Walnut Street. It would appear that construction is not yet complete.

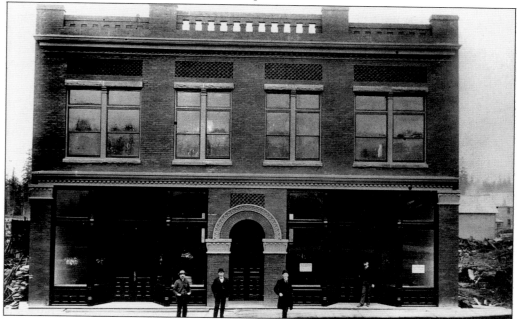

On March 21, 1892, the Brue Building is nearing completion. Located at 3010 Everett Avenue, it was designed for John Brue by renowned local architect F. A. Sexton. Photographs taken two months later show the building being used as a school.

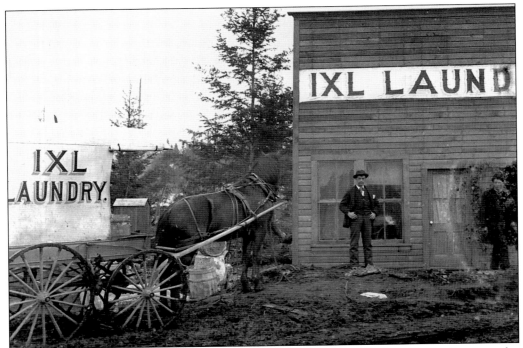

This 1892 photograph of the IXL Laundry was taken by King and Baskerville Studios. Laundry businesses usually did well in boomtowns where most men had no womenfolk to scrub their shirts for them. The IXL Laundry also featured a horse-drawn truck to pick up and deliver loads from door to door.

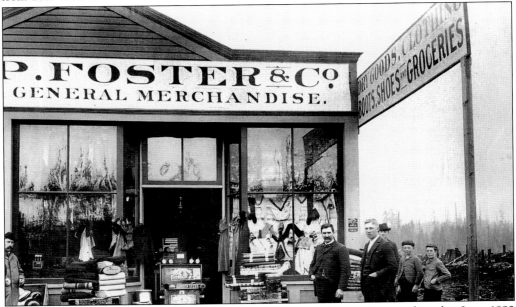

Before the advent of the supermarket there was the general store. Featured in this June 1892 photograph, the P. Foster and Company General Merchandise offered dry goods, clothing, shoes, boots, and groceries. A garden seed display is also clearly visible among the stock.

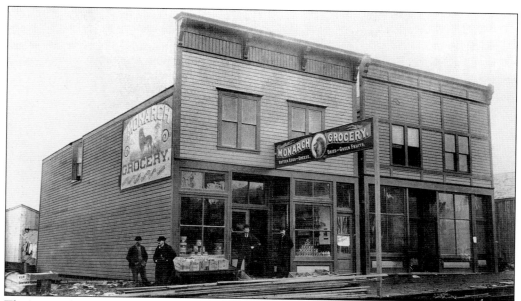

The Monarch Grocery was just that, a grocery without dry goods. It advertised butter, eggs, cheese, and produce. Their side sign offers tobacco cigars and crockery. The living quarters above the grocery seem to be for rent.

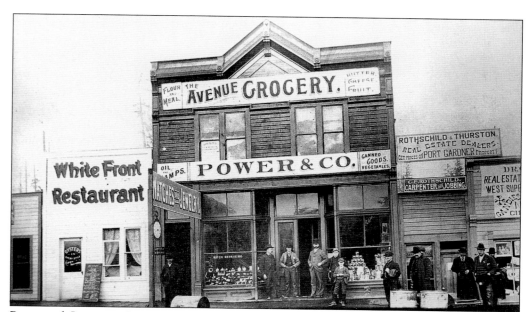

Power and Company Avenue Grocery sits surrounded by new businesses on busy Hewitt Avenue between Walnut and Chestnut Streets. The White Front restaurant to the left offers oysters in every style. A watchmaker is nestled between the grocery and the restaurant while above is the shop of a dressmaker. On the right is a carpenter shop flanked by more real estate offices.

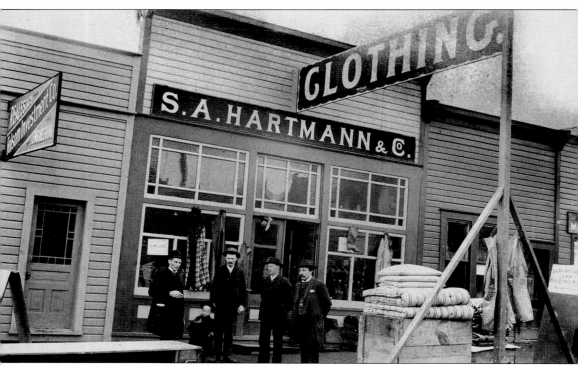

S. A. Hartmann and Company provided clothing and sewing services from their shop on Hewitt Avenue near Chestnut Street. Mattresses and boots are also displayed. Rather unsurprisingly, the business is flanked by two real estate offices. This photograph was taken in March 1892.

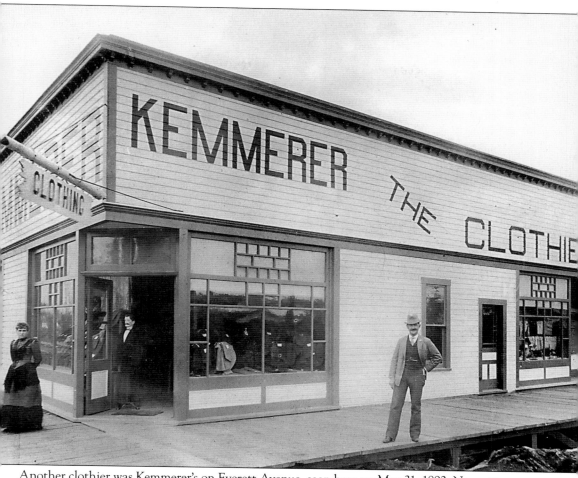

Another clothier was Kemmerer's on Everett Avenue, seen here on May 31, 1892. No mattresses are stacked outside this store. Instead there is a mannequin in evening dress just inside the door and what looks like a seal skin shoulder cape displayed in the window. Kemmerer's appears to be a step above Hartmann's establishment.

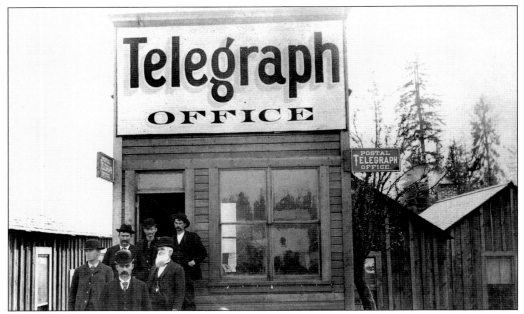

Communication was important in the new city. Faster than mail was the telegraph, and Everett's telegraph office was located on Pacific Avenue. Less than two years after this photograph was taken, Marconi would successfully experiment with "wireless." The telephone was soon available in early Everett.

The new newspaper in town, *The Everett Herald*, would have reported any news flashes to the community. The *Herald* office was located at California and Chestnut Streets. Here the staff poses on the doorstep as though they are ready for the next scoop. The *Herald* is still the main daily paper in Everett.

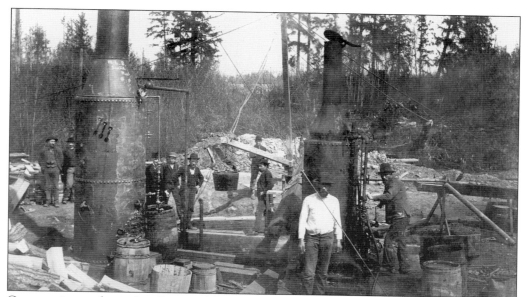

Construction on the city's well was in full swing by the time of this photograph from April 10, 1892. Eventually the water demands of the pulp and paper industry would drive the city to develop a more efficient water system.

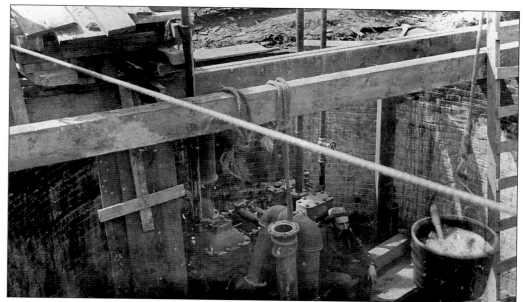

This interior shot of the well clearly shows the brick and mortar construction.

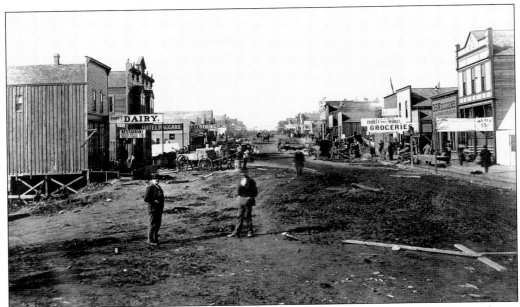

By March 1892, Everett was beginning to look like a town instead of a wasteland. This west-facing view displays Hewitt Avenue. Even in its infancy, the street was a busy thoroughfare. Wooden sidewalks and more businesses are under construction. It would not be long before planked streets would replace the muddy roads.

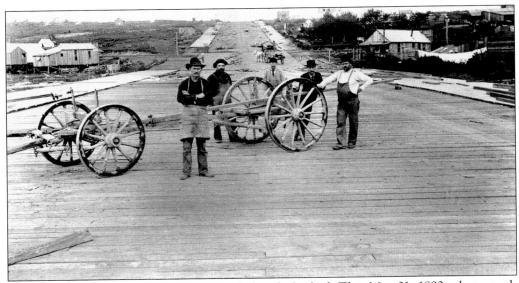

W. G. Swalwell had Hewitt Avenue graded and planked. This May 31, 1892, photograph shows men working on the planked roads, looking east on California Avenue. Plank roads had been common in the United States since the middle of the 19th century, but the cost of maintaining them was prohibitive.

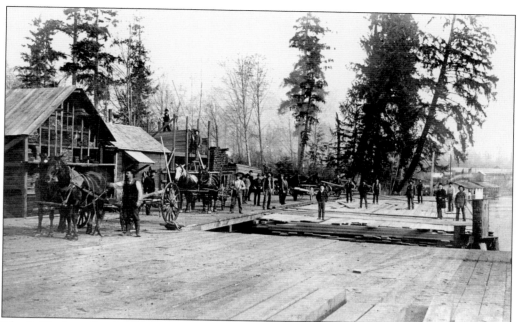

The Bellingham Bay Lumber Company was located on the Snohomish River at the foot of Pacific Avenue in Everett. By 1907, the company would be one of the world's largest sawmill firms. In this 1892 photograph, several sizes and grades of their product can be seen. Some are surely destined for the planked roads of the growing city.

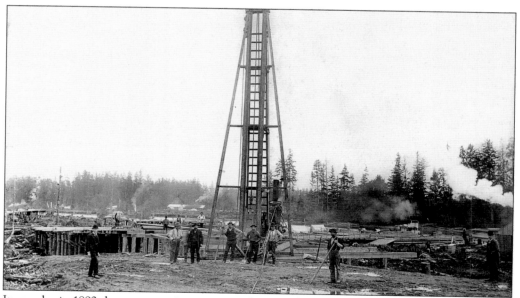

It was also in 1892 that construction was started on another bridge for the Snohomish River—the Everett Avenue Bridge.

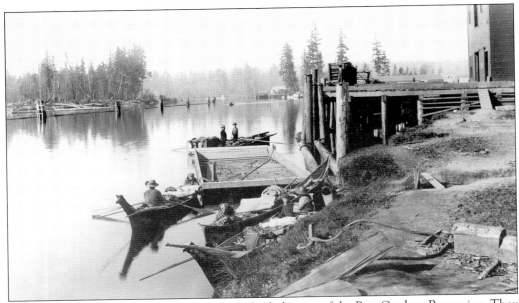

Native Americans were, of course, the original inhabitants of the Port Gardner Bay region. They had been forced onto a reservation a few miles north of the city following the Indian Wars of the 1850s. Although racism was rampant in the early days of Everett, the sight of tribal canoes coming into the docks would not have been unusual. This April 13, 1892, photograph was taken at Spithill's Wharf.

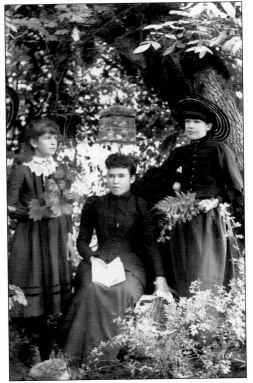

It is doubtful that the mother and daughters, posed in this 1892 portrait, ever met any of the local Native American population. They probably saw them in town but would never have dreamed of striking up an acquaintance. The prevalent racism of the day forbade it.

Two

BUILDING A CITY

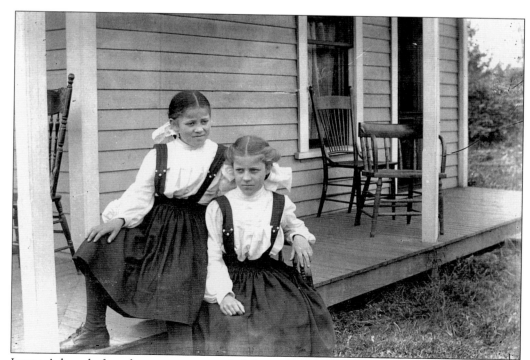

It wasn't long before the newcomers settled down. People built or rented houses. Schools and shops were new and fresh. The economy was good in 1892 and hope still existed that James J. Hill would soon bring the Great Northern Railroad to Everett. But it's possible that the parents of these girls had begun wondering why Hill was hesitating to complete the line.

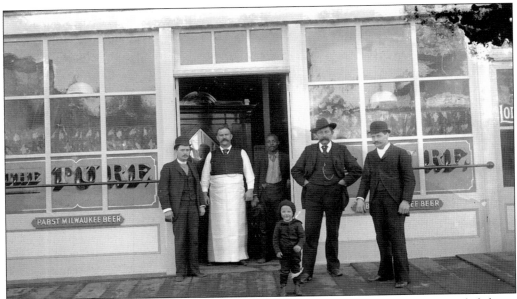

Regulars at the Turf Saloon on Everett Avenue probably discussed the civic situation on a daily basis. James J. Hill had visited Everett in February 1892, yet the town seemed no nearer to getting the railway connection they craved. Whispers of worry were now spreading throughout the town..

For merchants such as A. M. Leighton, business would have been steady even without the promised railroad. Making and repairing shoes was a skilled trade. Rubber soles had recently been invented. In 1892, several rubber companies consolidated to create the U.S. Rubber Company to meet the demand for the new product.

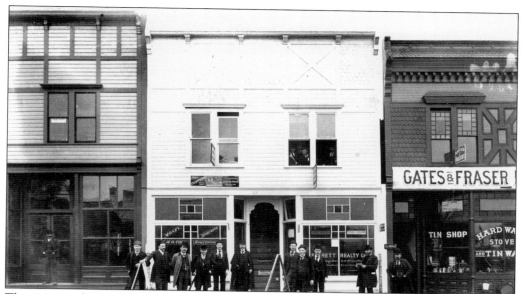

The citizens who would have been most worried about the delay of the railroad would have been those who owned and operated the numerous real estate offices. The Everett Realty Company was located on Hewitt Avenue near Chestnut Street. This photograph was taken soon after it opened in February 1891.

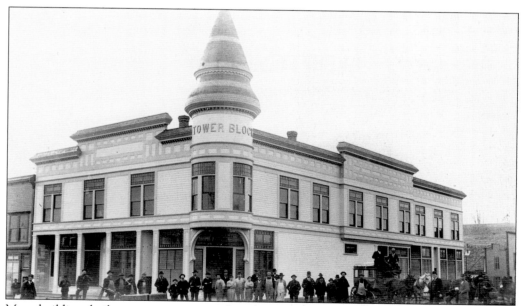

Many buildings built were very ornate, such as the Tower Block on the southeast corner of Hewitt Avenue and Chestnut Street. It was designed by Frederick A. Sexton and W. Black. At the end of the 19th century, it was cut in half and moved to the southeast corner of Hewitt and Rucker Avenues, where it was reassembled and survived many more years.

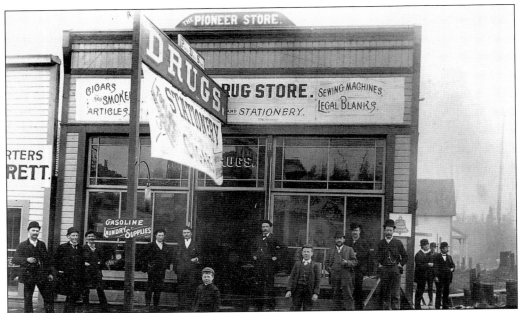

The Pioneer Store on Hewitt Avenue near Walnut Street advertises long-distance telephone service in addition to selling stationary and cigars. It also served as a drugstore. Such varied items as sewing machines, laundry supplies, and gasoline were among their stock. This March 2, 1892, photograph was probably taken at the grand opening.

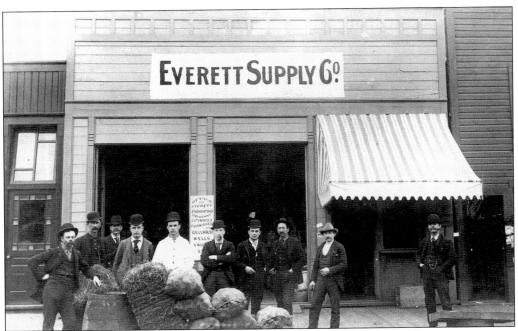

The Everett Supply Company on Hewitt Avenue also housed the office of the Everett Excavating Company, seen here in March 1892. Supplies seem to be of the feed store variety. Services offered by the Everett Excavating Company included digging wells and cellars.

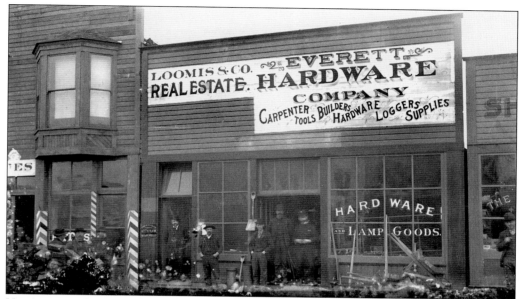

Here's yet another real estate office. Sandwiched between the barbershop and Everett Hardware, with ploughs, pumps, and shovels on display, is Loomis and Company Real Estate. Loomis and Company offered attorney and notary service in addition to real estate sales.

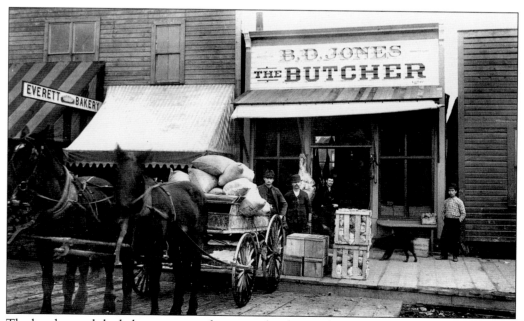

The butcher and the baker were next door to each other in this May 1892 photograph of Hewitt Avenue near Walnut Street. Clearly visible in the lower right corner is the end of planked road, which was still under construction. Cabbages fill the open crates on the sidewalk.

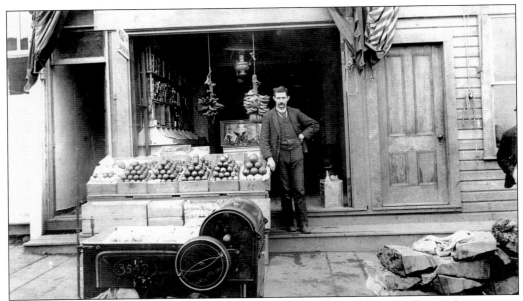

Bananas apparently came in ripe and very ripe at Mangarella's Grocery on Hewitt Avenue near Walnut Street. One can assume that the owner, Frank Mangarella, is the man leaning against the boxes of fruit in late spring or the summer of 1892.

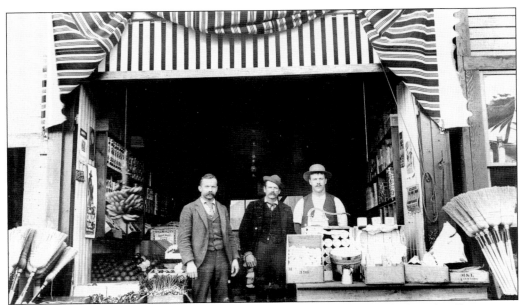

One of Mangarella's competitors also has bananas on display. Between the barrels of brooms are eggs, spring onions, and lettuces. This store was located on Hewitt Avenue near Market Street.

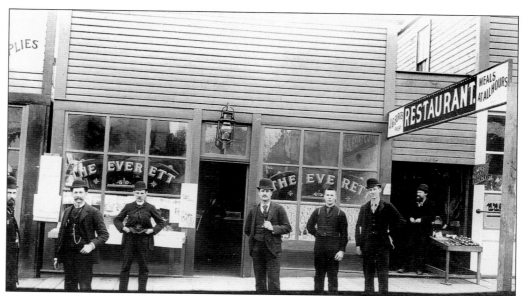

The Everett Short Order Restaurant was located on Hewitt Avenue near Chestnut Street. Owned by "Burger and Jackson," the sign indicates that meals were available at all hours. A lantern hanging over the doorway suggests they did indeed get some night trade. Barely visible to the left is the Everett Hardware Company and on the right was a laundry.

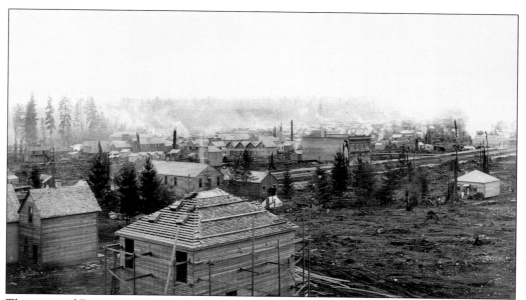

This view of Everett Avenue from the Riverside Neighborhood shows the progress that had been made in the developing city. The photograph was taken in February 1892, about a year into the construction of the town. It was the same month that James J. Hill visited the town and then left again, without committing himself to putting the final stop of the Great Northern Railroad in Everett.

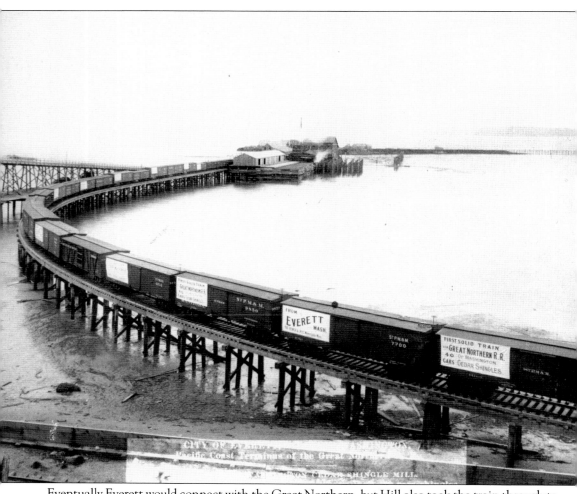

Eventually Everett would connect with the Great Northern, but Hill also took the train through to Seattle. It wasn't what investors had planned. This was not the only factor in Everett's downfall— the financial panic of 1893 hit as well. Here the first trainload of shingles leaves from the Fourteenth Street dock.

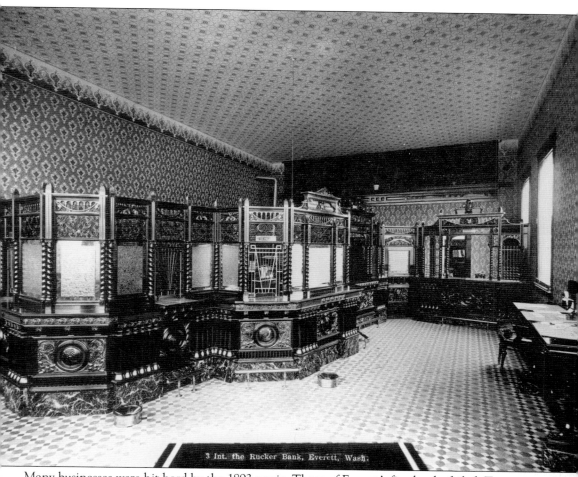

3 Int. the Rucker Bank, Everett, Wash.

Many businesses were hit hard by the 1893 panic. Three of Everett's five banks failed. Two men that survived the panic and continued to enjoy financial success were the Rucker brothers. This interior shot of the Rucker Bank was taken around the end of the 19th century. Wyatt Rucker was the bank president and his brother Bethel was listed as a cashier. The building, at 1602 Hewitt Avenue, is now a Bank of America. The Rucker Bank was not the only investment made by the family. They were involved in several business enterprises. Bethel Rucker's wife and children later donated Rucker Hill Park on Laurel Avenue to the city.

The Pacific Steel Barge Company would never utilize this company boardinghouse to full capacity—a steel strike in the east put a halt to construction on the whaleback ships. Only one ship, the *City of Everett*, was turned out by the workers. Before the steel supply issue was fully resolved, the panic of 1893 hit.

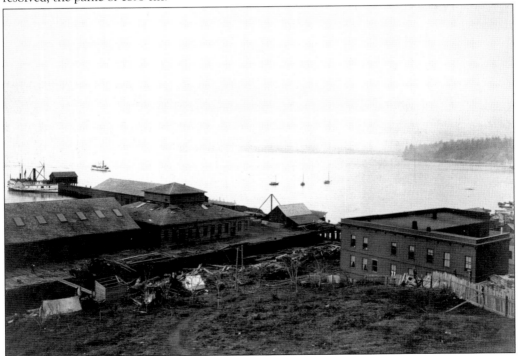

One business that managed to survive the 1893 depression was the Puget Sound Wire Nail and Steel Company. Flushed with the success of selling nails for the 1892 boom, the company was forced to temporarily close during the worst of the depression, but reopened in 1895.

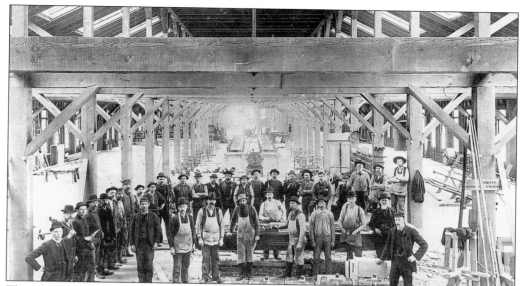

This photograph of the workers at the Puget Sound Wire Nail and Steel Company was taken before the 1893 financial panic. The factory was said to be a model one with all of the latest laborsaving methods employed. The nail works could produce everything from the smallest brad to a thirteen inch spike.

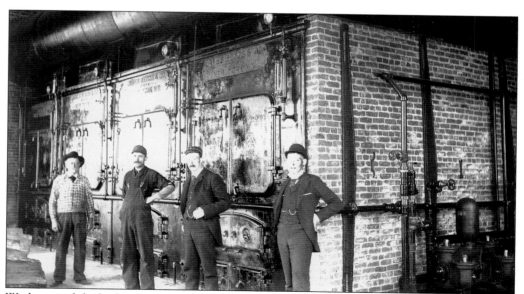

Workers tend the boiler room at the Puget Sound Wire Nail and Steel Company. The boiler house was built of brick and said to be fireproof. The boiler room fire went out for the last time in 1899, after the company was bought out and shut down by its biggest rival—U.S. Steel.

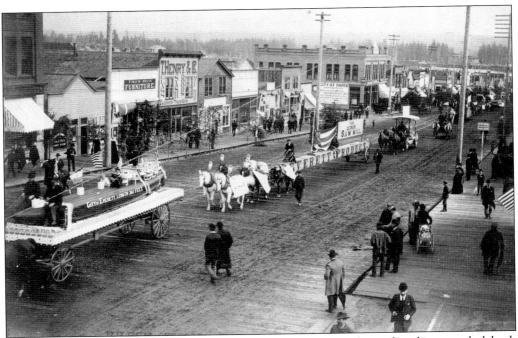

There was a glimmer of hope during hard times when the barge works produced its one whaleback ship, the *City of Everett*. An industrial parade took place on October 24, 1894, to celebrate its launching. The float pictured here on Hewitt Avenue between Pine and Maple Streets features a model of the vessel.

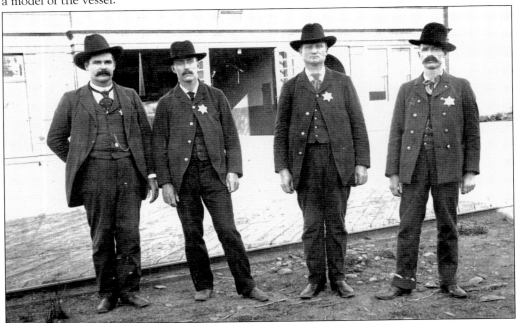

Patrolling the streets during the *City of Everett*'s launch would have been Officer Frank P. Brewer. He stands second from the left. Brewer served on Everett's police force from 1893–1895. Standing with Brewer are fellow police officers J. S. Borland, J. W. Farrar, and Louis Larson.

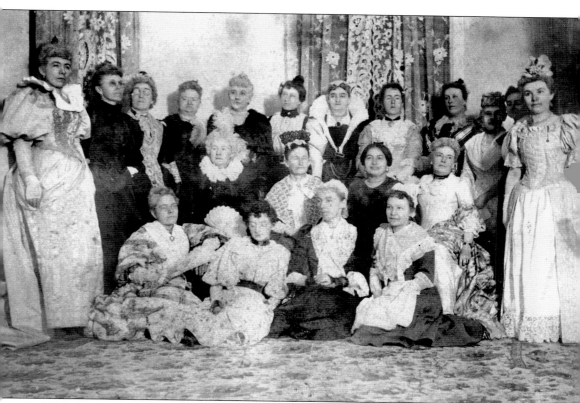

By 1895, the Everett Women's Book Club was in full swing. This colonial tea party was held in the ladies' parlor of the Monte Cristo Hotel on Washington's birthday and was said to be the club's first official meeting. The ladies, from left to right, are (first row) Mrs. Squire Sears, Mrs. Joseph Irving, Mrs. C. C. Brown, and Mrs. Edward Bailey; (second row) Mrs. Elmer E. Lytle, Mrs. J. B. Crooker, Mrs. W. R. Stockbridge, and Mrs. Stephen Knowlton; (third row) Mrs. John T McBride, Mrs. Robert McFarland, Mrs. Thomas Garrigues, Mrs. Schuyler Duryee, Mrs. Edward Mills, Mrs. Charles P. Thomas, Mrs. David Power, Mrs. Arthur K. Delaney, Mrs. Augusta Plummer Foster, Mrs. Charles Marshall, Mrs. J. T. Lentzy, and Mrs. J. M. Vernon.

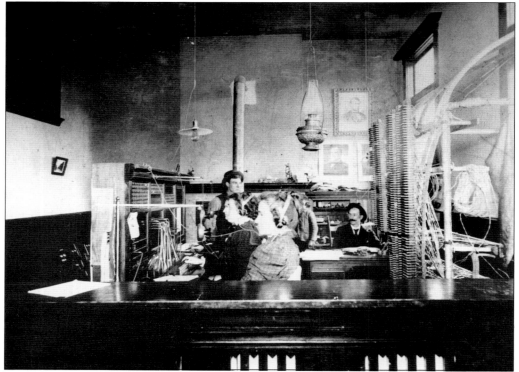

By 1896, the Everett Telephone Exchange was in service. Here operators work to manually connect calls on the switchboard. By 1900, almost all telephone operators in the United States were women. Early telephone exchanges employed boys to do the work but found that they tended to be rude and played practical jokes on callers. Women were thought to be more polite.

As families began to recover from the 1893 depression, more houses began to spring up in town. A new row of private homes sits at the corner of Rucker Avenue and Twenty-third Street.

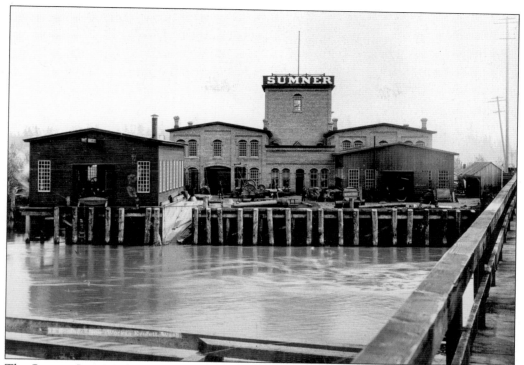

The Sumner Iron Works opened in the midst of the 1893 depression and survived throughout. Brothers F. W. and Thomas Sumner opened the factory, which stood at the east end of Everett Avenue. They manufactured ore from the Monte Cristo mine and, by the time this photograph was taken at the end of the 19th century, had fulfilled lucrative contracts from the Klondike gold rush. They produced a variety of products.

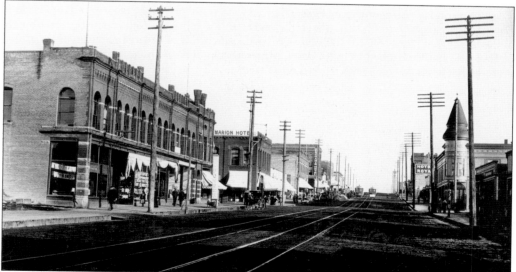

This 1898 view of Hewitt Avenue, with the Marion Hotel, the Merchant Hotel, and the Hotel Royal, looks east from Grand Avenue. Streetcars now run up the roads of Everett. Dominating the skyline to the right is the ornate spire of the Tower Block at Chestnut Street.

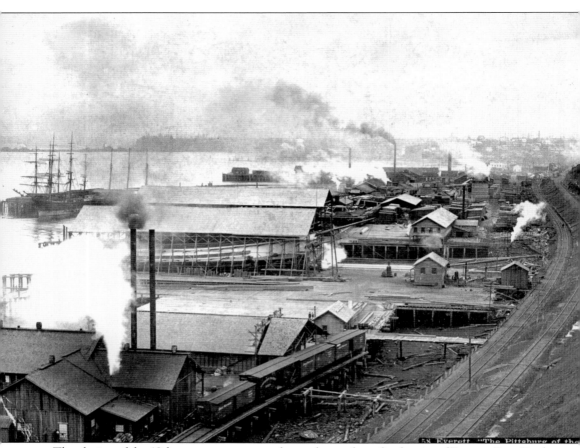

The closing of the 19th century saw a very changed waterfront for the city of Everett. Port Gardner Bay was now a busy hive of boathouses, mills, and factories. It had almost become the "Pittsburgh of the West" that Henry Hewitt had envisioned a decade before. The city had survived the panic of 1893 and had continued to grow, despite the setbacks. The 20th century blossomed full of promise, but it would come with its own set of trials.

Three

A NEW CENTURY

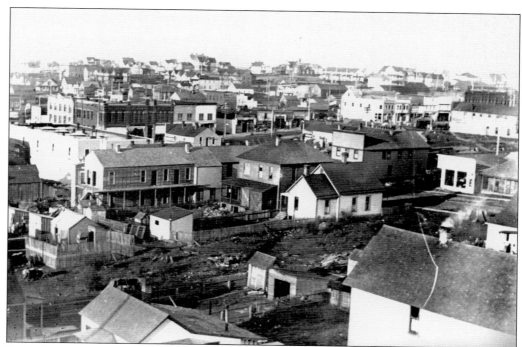

Ready for a new century and looking more like the Everett of today, this photograph faces northeast from Wall Street. The city is now well established. The 1900s will bring more challenges, but the people of Everett will continue to meet them head on.

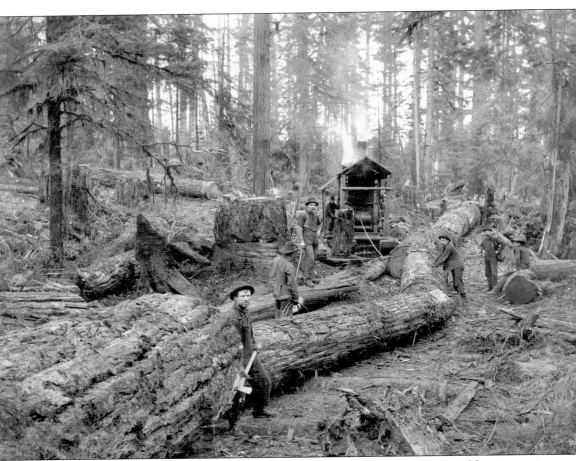

At the beginning of the 20th century, logging was still a major industry in Everett. New innovations were being made all the time, as evidenced in this 1900 photograph of men operating a steam donkey. It was a newer type of machine that replaced the old method of hauling logs with oxen or horses. It worked by a stationary steam engine powering a winch that hauled the logs along the logging roads. While the new invention was a labor saving boon, many loggers were injured or killed when getting in the way of the donkey's cable.

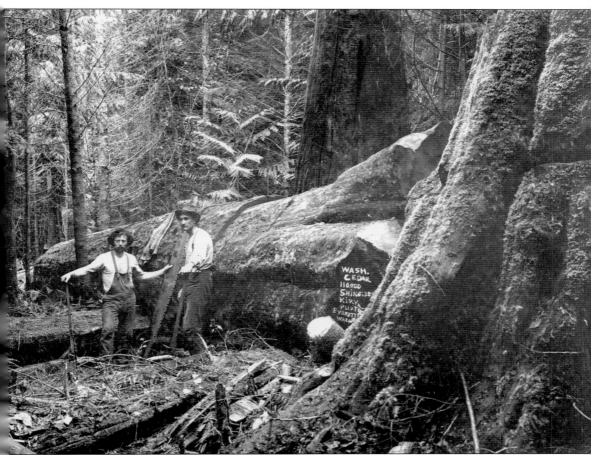

Everett was famous for its shingles that were hewn from Douglas fir or Western Red cedar. Millions of shingles were turned out every year and sold worldwide, both by large mills and small private operations. San Francisco was a big buyer of long-lasting northwest shingles. It was a booming industry that kept many employed. The caption on this photograph from George Kirk Studios reads, "Washington Cedar 110,000 shingles."

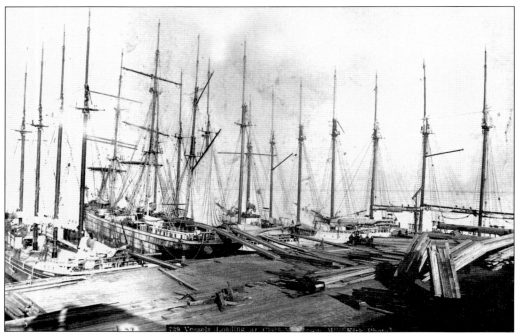

This 1902 line engraving from Kirk Studios shows lumber being loaded onto ships from the Clark-Nickerson Mill. Record amounts of lumber and shingles were pouring out of the Everett mills. Accordingly, there was a price drop due to overproduction. Many mills ran 24 hours a day to make up for the loss in profits.

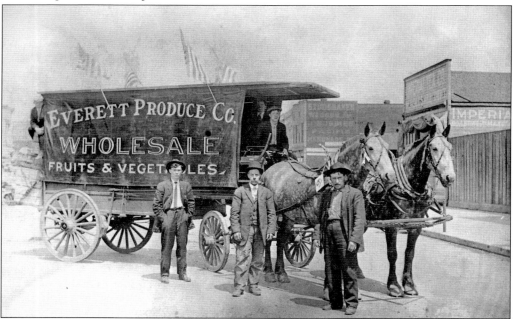

The roads of Everett were much easier to navigate by the early 20th century. The Everett Produce Company's delivery wagon is on the northeast corner of Hewitt and Rucker Avenues. O. B. "Dick" Dickinson, center, is said to be the driver.

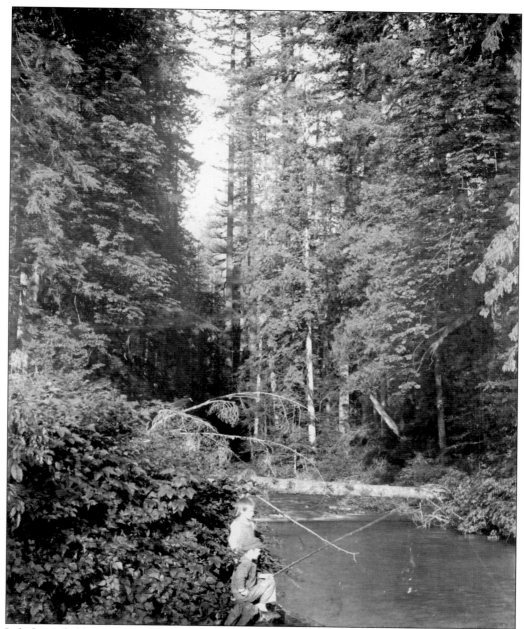

Life for a child in early Everett had its perks. These boys fishing along a creek in 1900 would have had a lot of fresh air and sunshine. There was undoubtedly more freedom to play outdoors then than there is now. On the other hand, diphtheria, whooping cough, and measles were common and often fatal illnesses for early 20th-century children. Infant mortality was high. Child abuse cases would have to be severe before authorities would consider stepping in to intervene. Improved nutrition was starting to have an impact, but vitamin deficiencies were still very common. Schoolhouses still had a single dipper or cup in a bucket of drinking water that was shared among all the children. Consequently they shared their germs as well. Antibiotics would not be developed until World War II.

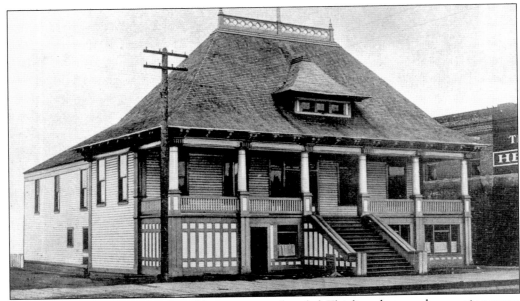

In 1892, the Everett Area Chamber of Commerce was founded. This line photograph engraving comes from the Kirk and Seely Studios Everett Souvenir Book of Photo-Gravures published in 1902.

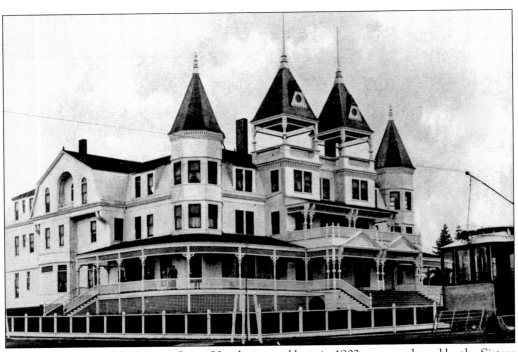

This first location of the Monte Cristo Hotel, pictured here in 1902, was purchased by the Sisters of Providence in 1904 and became Providence Hospital. The building was demolished in 1923 to make way for a more modern facility. The "newer" Monte Cristo Hotel is still located at 1507 Wall Street. Historically the Monte Cristo was a social center for the elite of Everett. Now it is an arts center and more.

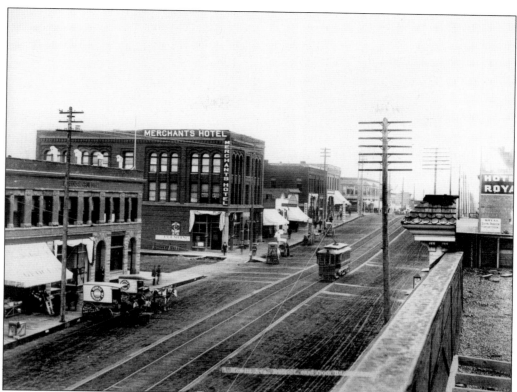

This 1902 view of Hewitt Avenue looks east past Hoyt Avenue. The horse-drawn wagons of the People's Grocery Company wait as streetcars pass by. At the extreme right of this picture is the edge of the Hove Building. Designed by architect Charles Hove, he opened the Hotel Royal in the building as something to do during his retirement.

Kirk and Seely Studios featured St. Dominick Academy in their 1902 booklet of photogravures. St. Dominick's used to be across from Our Lady of Perpetual Help Catholic Parish. It is the oldest Catholic parish in Everett and dates back to 1891. Although none of the original buildings are standing, the parish on Cedar Street is still active and still houses a school.

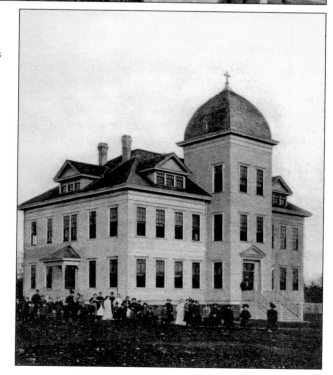

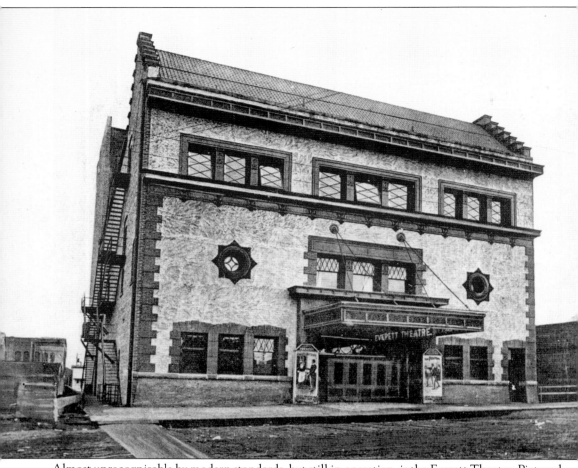

Almost unrecognizable by modern standards, but still in operation, is the Everett Theatre. Pictured here in 1902, it was an ornate opera house that attracted the finest of performers. Big names that once played at the Everett Theatre include Al Jolson, Helen Hayes, and George M. Cohan. The building was damaged by fire in 1923, but was rebuilt with new facade features that many Everett residents would find familiar today. It also underwent several interior remodels (some pleasant, some not). It became a movie theater and at one point had the internal elements butchered to create a triplex movie theatre. For a while, the building stood abandoned. Fortunately a dedicated group of friends and volunteers have restored the Everett Theatre to its past glory. The building is once again a live performance venue with an active theatre company. The Historic Everett Theatre is located at 2911 Colby Avenue.

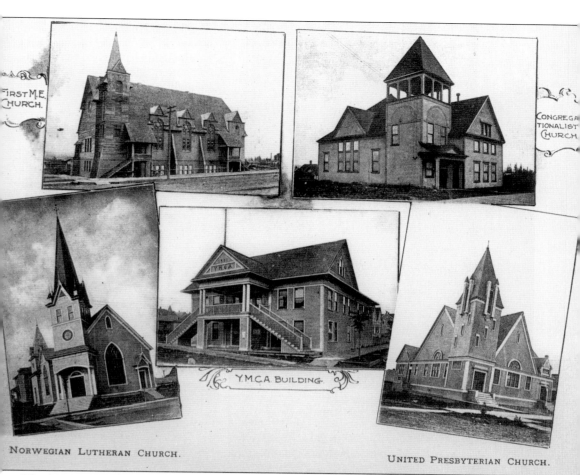

FIRST M.E. CHURCH.

CONGREGATIONALIST CHURCH.

Y.M.C.A. BUILDING.

NORWEGIAN LUTHERAN CHURCH.

UNITED PRESBYTERIAN CHURCH.

The first citizens of Everett immediately organized churches. The oldest established church in Everett is the First Presbyterian Church, whose original wooden structure was built in February 1892 on Maple Street. Five years later, the church relocated to its permanent and still active location on the corner of Rockefeller Avenue and Wall Street. Although still a vital part of the city, churches probably played their most important role during the formative years of Everett. Through them, people gained a sense of belonging in the new community. Friends and connections were made, and immigrants kept contact with their native language and customs. The churches of Everett were featured in the 1902 Kirk and Seely Studios *Everett Souvenir Book of Photo-Gravures*.

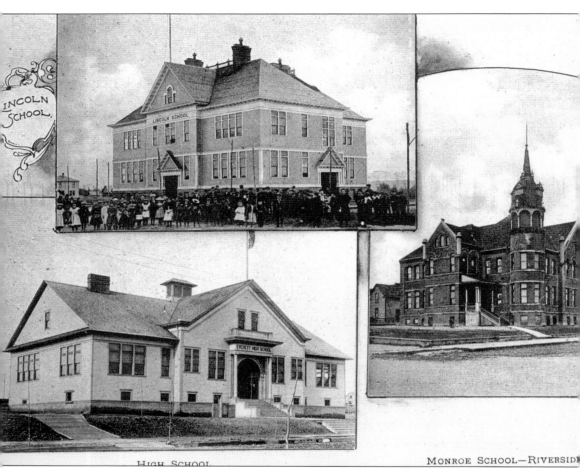

This 1902 photograph engraving features some of the schools in Everett. In the late 19th and early 20th centuries, school buildings tended to be sparsely decorated. Students were responsible for bringing their own books and supplies. It wasn't until 1905 that voters agreed that textbooks should be provided by the schools themselves. Even so, many students did not progress beyond the primary grades, preferring instead to leave school and find work to assist their families. In 1910, Everett High School, as seen in the lower left of this photograph, would be replaced by a more substantial structure. That later building is still in use today at 2416 Colby Avenue. In 1997, it was placed on the National Register of Historic Places.

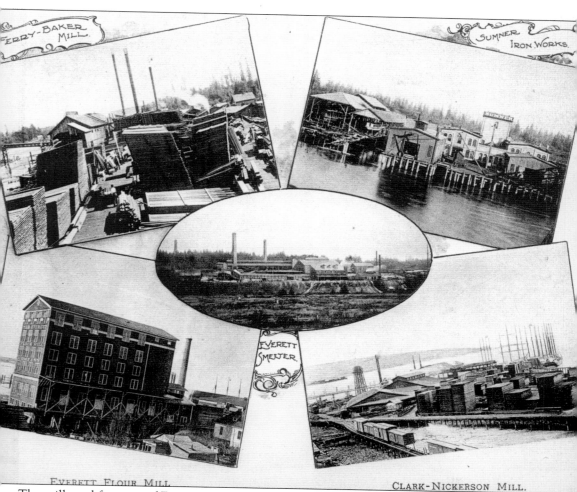

The mills and factories of Everett were the city's life blood. This page from the Kirk and Seely Souvenir of Everett book depicts some of the more notable businesses of the era. The Clark-Nickerson Mill was founded by David Clough and would eventually cover 60 acres in Everett's waterfront area. Considered a model mill, it produced both lumber and shingles, and competed successfully in an international market. In 1893, the Sumner Iron Works opened. It manufactured mining and mill equipment. The company operated successfully under the same name until the 1960s. The Everett Smelter was originally established to refine ores from the Monte Cristo Mine. John D. Rockefeller sold his interests in the smelter the year after this photograph was taken. It closed seven years later.

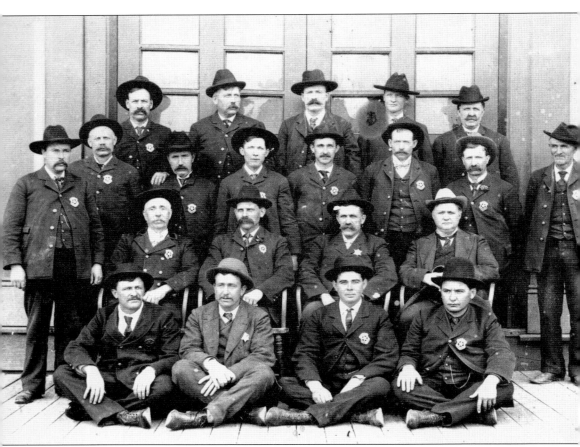

This *c.* 1903 photograph of the Everett Police Department was a gift to Snohomish County from Charles Barry. Officer Barry is seated second from the left in the front row. He also worked as a steam engineer. Seated next to Barry, second from the right is Deputy Jeff Beard. Deputy Beard would lose his life in the line of duty during the Everett Massacre of 1916. The other gentlemen, from left to right, are (first row) Herb Williams, Charles Barry, Jeff Beard, and unidentified; (second row) jailer J. McDonald, W. E. Jones, unidentified, and Chief Kraby; (third row) U. R. Hodgkins (?), J. G. Harling, H. S. Holberg (?), C. E. Goldthorp, J. D. Fox, J. O. Williams (?), G. C. Kiehl, and unidentified; (back row) unidentified, C. F. Knapp, J. O. Williams (?), S. Marshall, and jailer F. Holcomb.

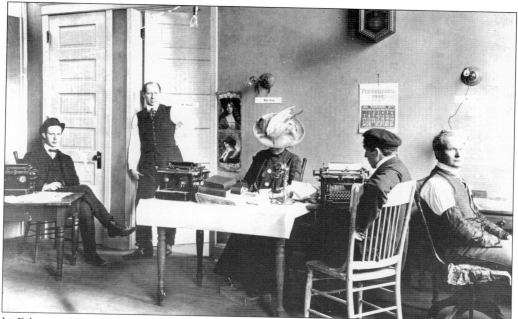

In February 1904, the staff of *The Everett Herald* appear ready for action. Editor Frank Wyman stands in the doorway, while reporter Hattie King works on her latest story. At far right, reporter Mark Flower is in his shirtsleeves, ready to jump on the latest scoop.

In the summer of 1907, an unidentified photographer visited many of the shops and businesses of Everett creating a time capsule on film. Left in the possession of the Everett Community College, they were later given to the Everett Public Library's Northwest Room to make them available to the public. This 1907 photograph of a living room is one of that collection.

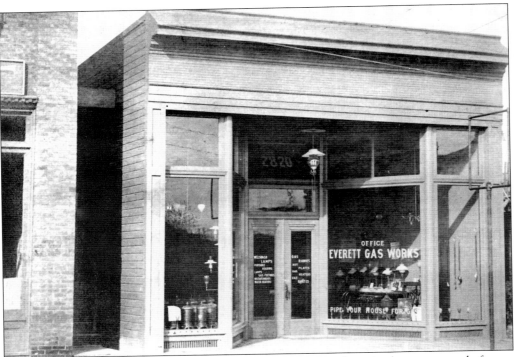

The Everett Gas Company at 2820 Colby Avenue was equipped to pipe houses not only for gas cooking ranges but also for gas lighting. This 1907 photograph was taken just as the popularity of gaslight was beginning to wane. Not surprisingly, many of the new electric fixtures manufactured at this time were copied after the fashion of the old gaslight fixtures.

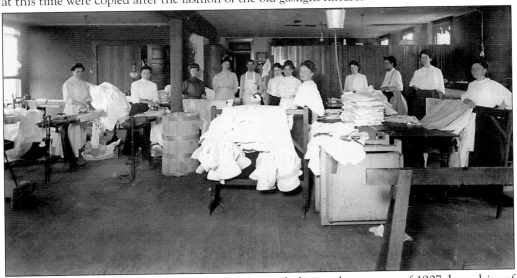

This laundry must have been an awful place to work during the summer of 1907. Laundries of the era were notorious for bad working conditions, including poor ventilation and extremely high temperatures. The job was hazardous due to poor sanitation, high humidity, and long-term exposure to cleaning compounds. Laundry work was poorly paid and generally considered "woman's work," even in an industrial setting.

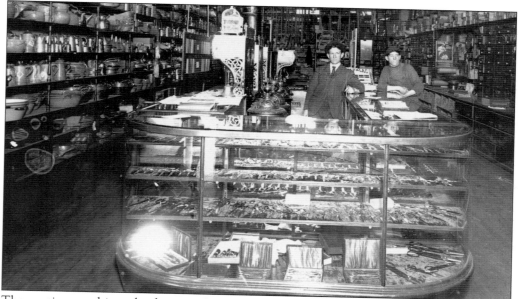

The caption on this early photograph identifies it as a department store, possibly Springer's Bazaar. It might surprise some to know that the concept of a department store is not a new one. The Bon Marche and Macy's had already been open in the United States for a few decades by the time of this 1907 photograph.

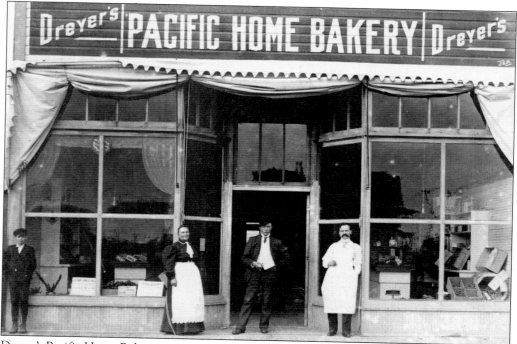

Dreyer's Pacific Home Bakery was in operation at the corner of Nineteenth Street and Broadway Avenue from 1908 until 1917. The owner was Thomas Dreyer. One can assume that the Dreyer family raised their own chickens to provide eggs for their products—one of the small signs in the window offers "laying hens for sale."

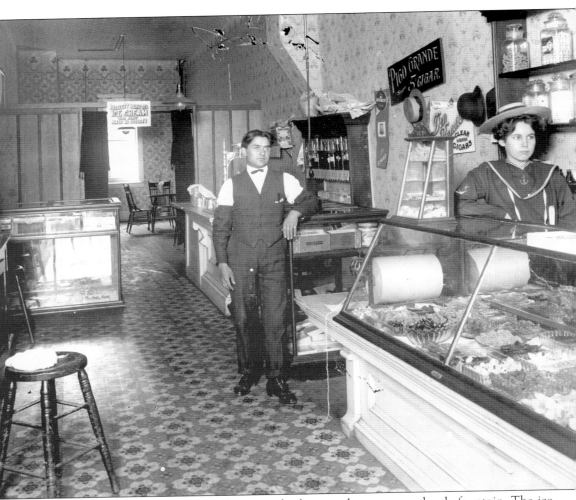

This 1907 Everett confectionery features a dazzling candy counter and soda fountain. The ice cream soda became popular in America during the latter 1800s, but it wasn't until the early 1900s that counter service fountains came into popularity. The soda fountain was not simply for children. It was an answer to the saloon for non-drinkers. Boxes of cigars are displayed at the side of this soda fountain for the adult male patrons. One can only guess at the types of candy sold, but clearly visible in the case are black licorice pipes that were popular at the beginning of the 20th century. Another popular treat in the early 1900s was the marshmallow—a heavier, stickier sweet than it is today. There are also signs in this shop to let customers know that the ice cream was from Bartlett Dairy and was the best in Everett.

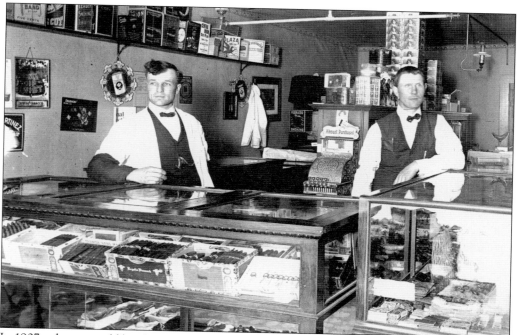

In 1907, tobacco could be obtained in any number of establishments. This photograph illustrates one of Everett's shops that sold tobacco products exclusively. Although chewing tobacco was extremely common, cigars were most popular and outsold cigarettes by far. Smoking was already coming under scrutiny as being bad for health and anticigarette and antismoking leagues were established.

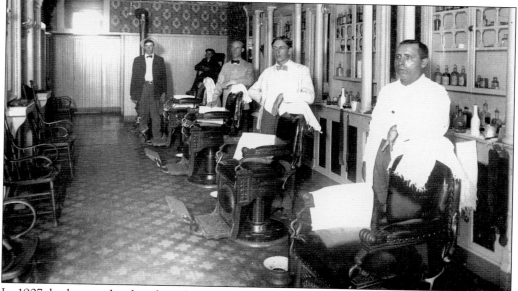

In 1907, barbers and a shoeshine boy wait to greet customers at Sharpless Barber Shop. Most barbers of the era would have been self taught or trained through apprenticeship, although the first official school for barbers actually opened more than a decade before. Note that each chair came with its own spittoon.

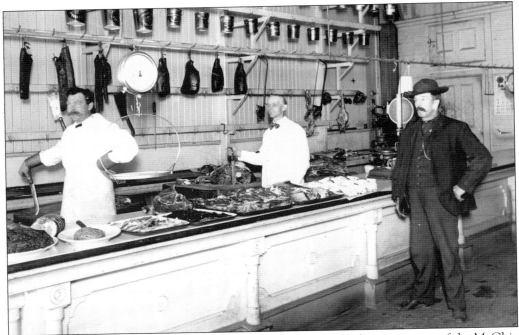

This may have been Fulton Market, or it may have been a shop belonging to one of the McGhie brothers. Whatever the case, fresh meat is on the display counter and buckets of lard and smoked meats hang from above. Upton Sinclair's book, *The Jungle*, published a year before this photograph was taken, describes the meat industry at the beginning of the 20th century.

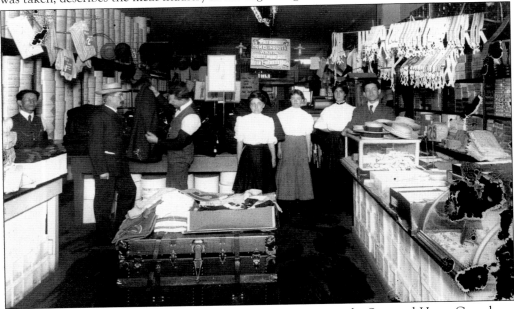

The Red Front Clothing Store at 2005 Hewitt Avenue was run by Sam and Harry Greenberg. Interestingly the sign asks customers to patronize home industry by wearing Everett-made shirts. Another sign suggests customers "ask to see our uncalled for suits." Presumably those are suits that were ordered, but not picked up. Men's suspenders are marked at 25¢.

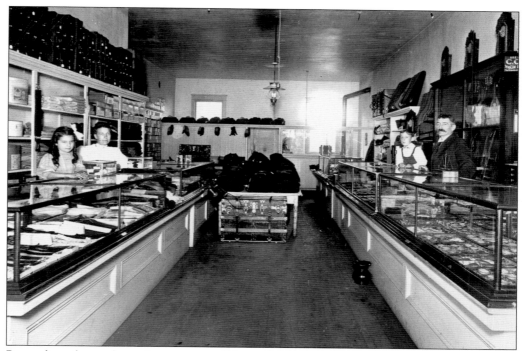

Pawn shops have always been a part of Everett's history. This is a picture of the U.S. Loan Company at 2905 Hewitt Avenue. The proprietors are Mr. and Mrs. Glassberg, with their children Abraham and Ruth. Pawnbroking came to America from Europe and was often the only way for people to obtain loans.

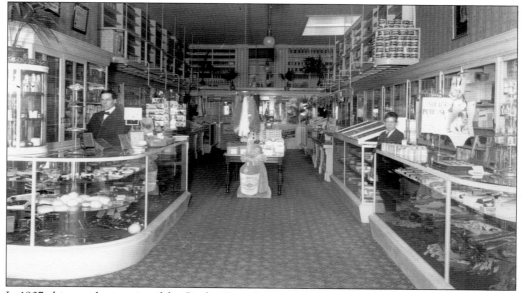

In 1907, this was the interior of the Quaker Drug Store at 1503 Hewitt Avenue, run by W. G. Shepard. Besides bath products and hair tonics, this store also features a large central advertisement for Pabst Malt Extract Tonic. Containing malt and hops, the tonic was produced by the same Milwaukee brewing company that made beer.

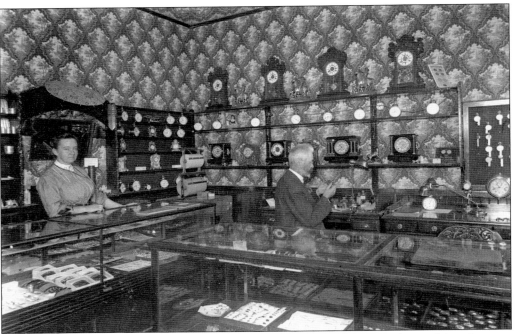

This 1907 jewelry store seems to have a wide array of timepieces. Most watches at this point were pocket watches. Although the wristwatch had been invented, they were not yet in mass production. The lady in this photograph is standing behind a case of hair combs and hat pins.

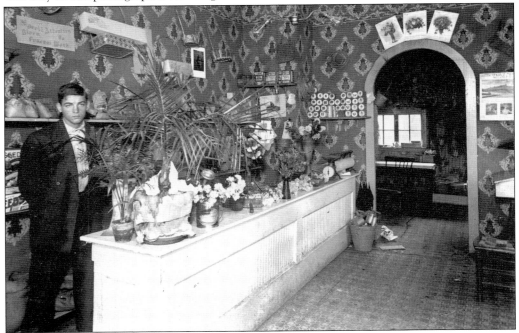

Peterson's Floral Shop advertises "special attention given to funeral work." Houseplants were starting to come into vogue about this time. The potted palms in front of the young florist were a popular choice, both at home or for special occasion displays.

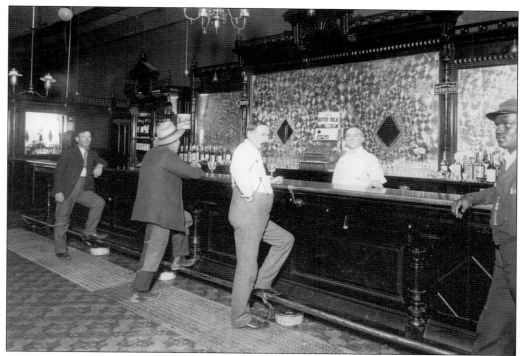

The Bodega Saloon, owned by Larry Mulligan, was one of many such establishments in Everett. By 1910, the mill town boasted over 40 saloons. But times were changing. The trend of the early 20th century was temperance and politicians were eager to jump on the morality bandwagon to gain votes. In 1916, the state of Washington State went dry until the end of Prohibition.

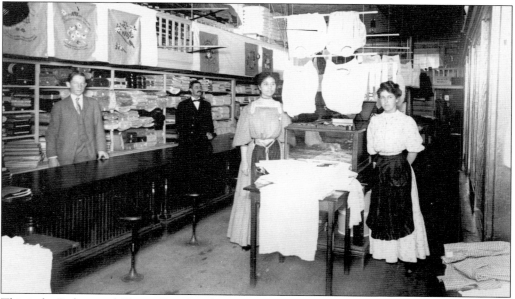

This is the Dolson and Cleaver Dry Goods store in the summer of 1907. Identified in the photograph are Miss Bachelder, second from the right, and Mr. Koblank, standing at far left. Dry goods refer to items such as cloth and sewing notions as opposed to groceries or other supplies.

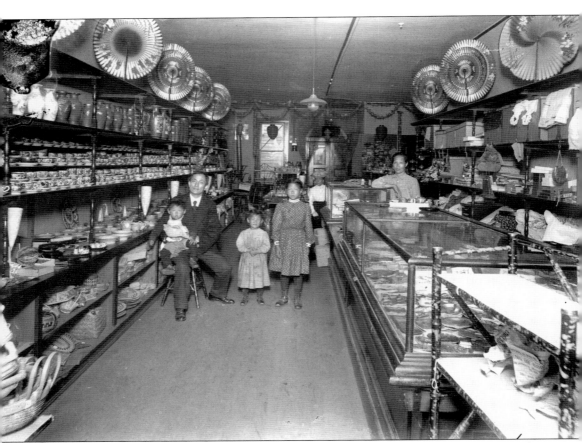

Owned by Charles Kan, the Japan Bazaar, located at 1410 Hewitt Avenue, sold Japanese novelties and fancy Oriental goods. Two of the children named in this photograph are Sam and Ruth Kan. The Kan family cannot have had an easy time living in Everett. Racism was rampant throughout the region and had long been accepted as "the norm." In 1885, Asians were banned from owning property and by February 7, 1886, a racist mob attempted to bodily expel the entire Asian population of Seattle, resulting in riots. The government was reluctantly forced to intervene. It is interesting to note that a reason frequently cited for hatred of minorities was their willingness to work for less pay, yet they were not given the option to work for equal pay. White male workers always earned more than minorities or women.

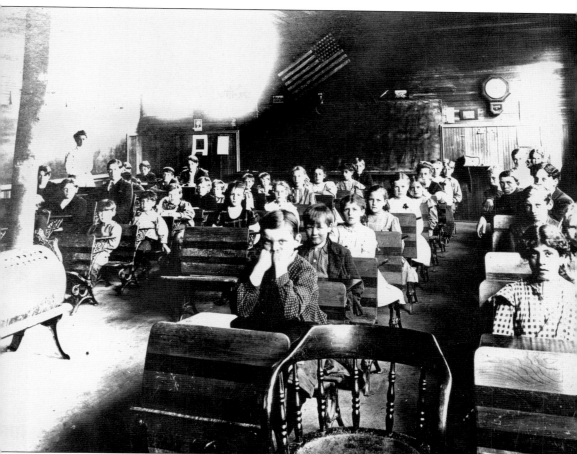

In 1908, children from the First East School in Everett wait patiently as a photographer takes their picture. The teacher standing to the left is Olive Mary Temple. The county superintendent was Eva V. Bailey. The children, from front chair to back, are (first row, far left) Norman Thompson, Matthew McNamara, Lloyd Gooden, and Harry Pettit; (second row, behind stove) an unidentified child in the front desk, Lewis Clark, Albert Abrahamson, George Schlilaty, Robert Mason, and William Cavalero; (third row) Norman Pettit, John Schilaty, Paul Pettit, George Clark, Joseph Howard, Roy Wadhams, and William Pearson; (fourth row) Signe Anderson, Beatrice Gourlay, Eleanora Bardon, Lena Cavalero, Marie Schilaty, and John Howard; (fifth row) William McNamara, Clarence Gregg, Hazel Mason, Eva Wadhams, Abby Howard, Emma Wadhams, Marion Pettit, Bertha Howard, and Ray Pearson; (sixth row) Sadie Schilaty, Thelma Bardon, William Howard, Lawrence Matthews, Elmer Pelton, Leonard Tennican, Grace Moreland, and Agnes Gourlay.

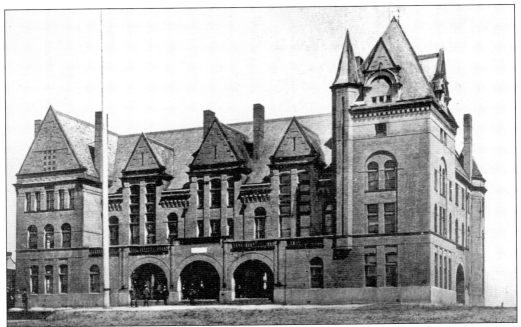

There were hard feelings in 1895 when Everett won the title of county seat from the city of Snohomish after a highly contested countywide vote. This 1902 photograph of the original county courthouse, designed by architect A. F. Heide, was taken by Kirk and Seely Studios. On February 1, 1898, the courthouse opened.

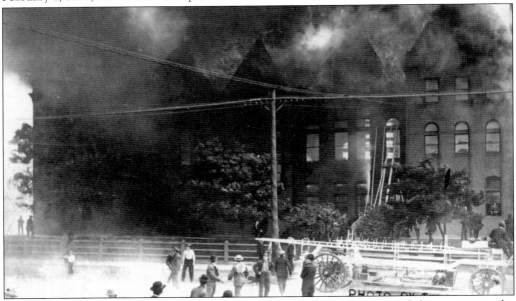

On August 2, 1909, the courthouse was destroyed by fire. It was determined that arson was the cause. Ironically Juleen Studios had completed a series of photographs featuring the Everett Fire Department standing in front of the courthouse just before the fire broke out. The city rehired the original architect for the rebuild, but opted for a Spanish Mission–style exterior rather than recreate its original facade.

This is a fire department vehicle from about the same period as the courthouse fire. The truck is from Station No. 3 at Nineteenth Street and Grand Avenue. It's likely that driver Anton "Tony" Minch was on duty the day the courthouse burnt down.

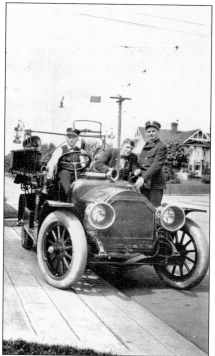

In 1911, these are the men serving the Everett Fire Department. Not all of the men are identified. Those who are, from left to right, include (first row) Charles L. Barry, ? Erickson, Charley Swanson, Chief Taro, Billy Swanson, and unidentified. In the second row, third from the left, is driver Anton "Tony" Minch.

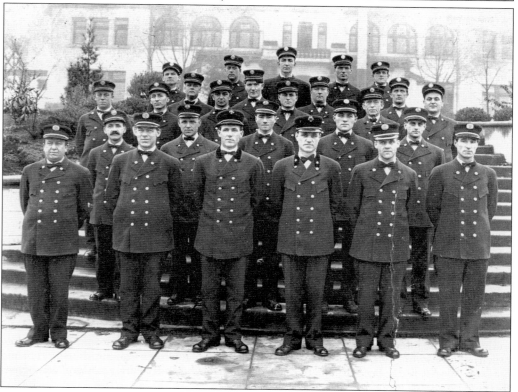

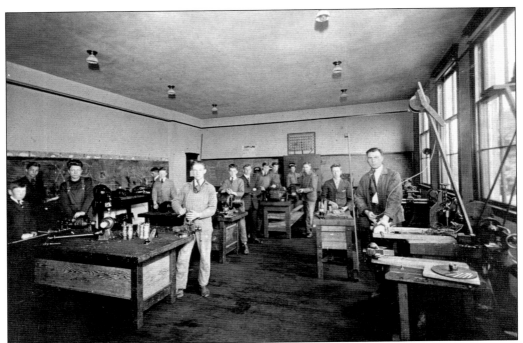

In 1910, the new Everett High School opened. Here is an electrical class in the vocational building's room E. The instructor was listed as Mr. P. O. Pettersen. Despite the new school, many students were still opting to drop out early and look for work among the mills and factories.

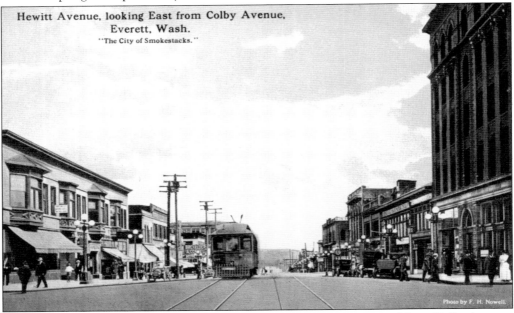

In this early 1900s postcard, streetlights line busy Hewitt Avenue eastward from Colby Avenue. Everett in this era is a solid industrial and union town. The factories and mills were running nonstop. Workers were becoming better organized and fighting for better working conditions and better wages.

Four

LABOR AND UNREST

Roland Hartley would be a key player, not only in Everett history but also in the history of the state. In 1910, he became mayor of Everett. Hartley was married to Nina Clough Hartley, daughter of David Clough of the Clough-Hartley Company, and they had three children—Edward, William, and Mary. The Hartley mansion still stands at 2320 Rucker Avenue and is a frequent venue for the arts.

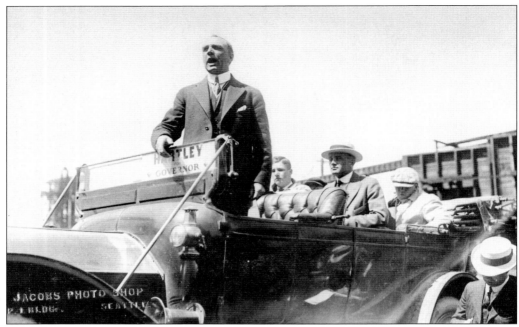

After a two year term as the mayor of Everett, Roland Hartley set his sites on a more ambitious political career. In 1915, he became a member of the Washington State House of Representatives. By 1925, Hartley was the governor of Washington. Here is one of his early campaign stops in 1916.

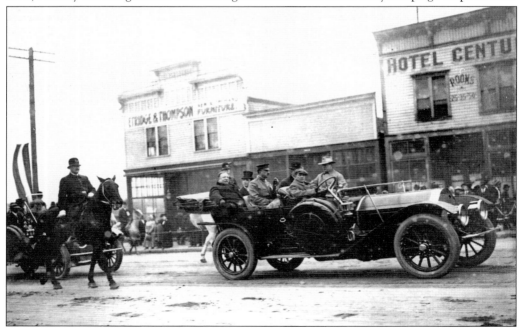

On October 9, 1911, President Taft visited Everett. He is seen here near the corner of Hewitt Avenue and Walnut Street. Seated next to the president is Mayor Hartley. Presidential military aide Maj. A. W. Butt is also in the car. On April 12 of the following year, Major Butt would become one of the victims in the sinking of the *Titanic*.

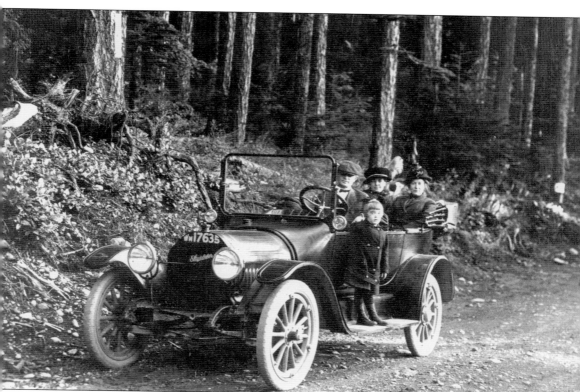

In 1912, future Everett mayor A. C. Edwards, is out for a family drive. Although Edwards would not become mayor until 1932, changes were happening in the Everett city government in 1912 that would have long-reaching effects. The 1912 charter created a city government made up by a group of three commissioners in the areas of finance, public works, and safety. The commissioner with the largest plurality would act as mayor in a ceremonial sense. The charter vote occurred during the term of Mayor Richard Hassell. Although an author of the charter, Hassell was seen as being soft. This was a view encouraged by former Mayor Hartley, who was incensed that Hassell's views did not line up with his own. Consequently, Hassell's mayoral term was cut short and he was not elected as a commissioner in the new system he had helped to implement.

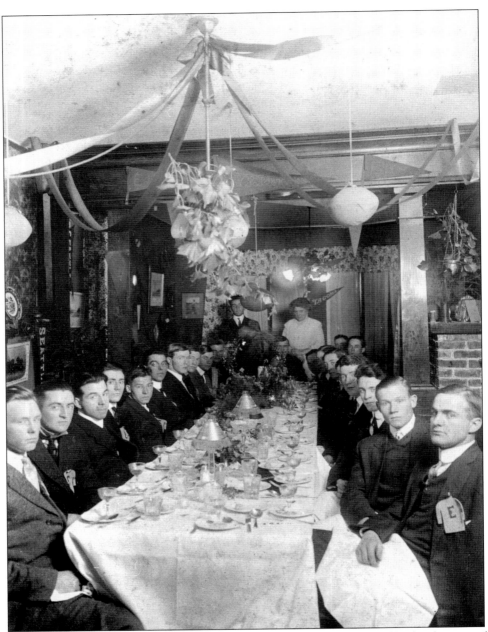

Nineteen hundred and twelve was a great year for Everett High School football. The championship team won every game but two. Of those two, one was a three to three tie with Queen Anne and the other a zero-all tie with Tacoma. Here the high school heroes enjoy their Thanksgiving Banquet. The notes on the back of this photograph indicate it was held at Phelan's. Fiske Phelan is on front right of the picture and was a key player during this era. Coach Enoch Bagshaw is sitting at the head of the table. Others players present include William Guerin, Irwin Dailey, Wallis or Walter Menzel, Chas Egan, Stub Costello, Gilbert Ballard, Morris Stevens, Eldon Drysdale, Zene Maulsby, Elbridge Fifield, Dan Michel, Jimmie ?, Bruce Talbot, Harry Lyke, Campbell ?, Ig "Orville" Merrett, Newts Dailey, ? Herrott, ? Lundstrom, Walter "Baldy" Kuhnle, and Larry Jones.

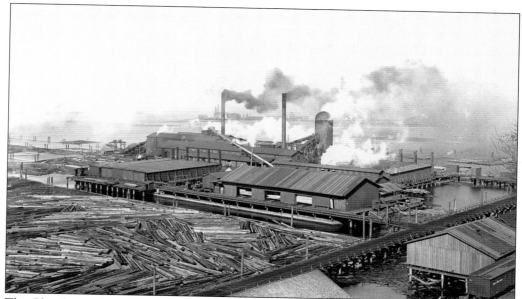

The Clough-Hartley Mill stood at the foot of Eighteenth Street. David Marston Clough was a timber baron from Minnesota. He brought with him trusted family members, including son-in-law and one-time protégé Roland Hartley. The Clough and Hartley clans were hardcore capitalists opposed to organized labor. As they owned several mills, this would be a factor in growing tensions prior to the Everett Massacre.

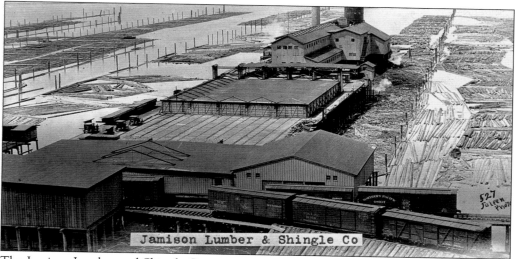

The Jamison Lumber and Shingle Company was located at Norton Avenue and Tenth Street. Owner Neil C. Jamison was not a man to mess with. When his workers went on strike, he simply brought in hired thugs to intimidate and, if necessary, beat picketers away from his mill. It is said that he joined in the beatings himself.

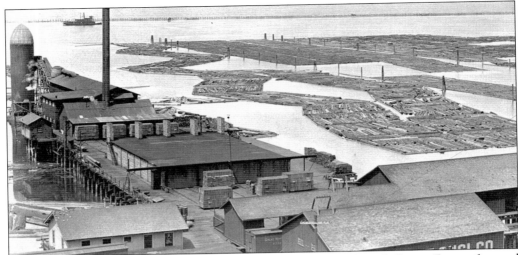

C-B Lumber and Shingle Company was located at the bottom of Tenth Street. Everett featured a number of such mills. The mill owners faced competition, strikes, and the ever-present danger of fire that could wipe out their livelihoods. They wasted little sympathy and even less money on their workers. The callous attitude of the owners fueled the upcoming labor showdown.

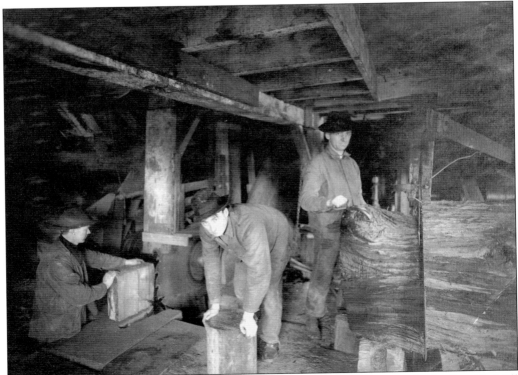

Workers inside the mills faced daily hazards. This photograph taken inside the Seaside Mill in Everett was used in an actual court case to demonstrate the danger of the saws. There was no such thing as a safety guard or safety equipment. Workplace injuries and fatalities were an everyday occurrence.

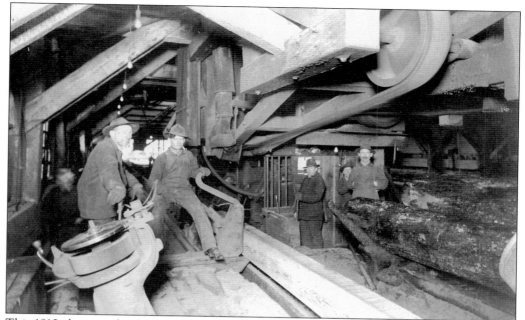

This 1910 photograph of the Clark-Nickerson Mill shows yet another example of how close the workers were to the machinery that could kill or maim them. Exhausted from working long shifts and with no room for safety, workers brushing against a moving belt could have their clothing caught up in the gears and be crushed. A slip or trip on an uneven floor could mean instant death.

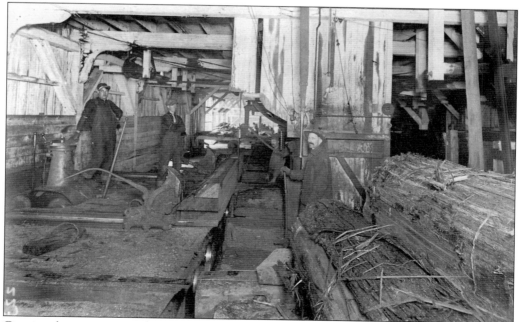

Continual exposure to airborne sawdust left many men with permanent and sometimes fatal respiratory conditions. It was little wonder that Everett workers were frequently on strike. This is another photograph from inside of the Clark-Nickerson Mill around 1910.

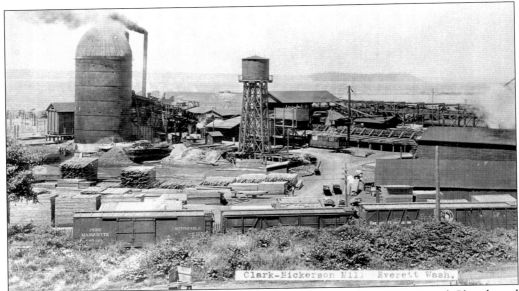

The Clark-Nickerson Mill was one of several enterprises operated by the united Clough and Hartley clans. As timber barons, neither family was a friend to labor. In order to turn a profit, they couldn't afford to be. But these families had political clout. Resentment against such mill owners was building to dangerous levels among Everett's unions when this photograph was taken in 1915.

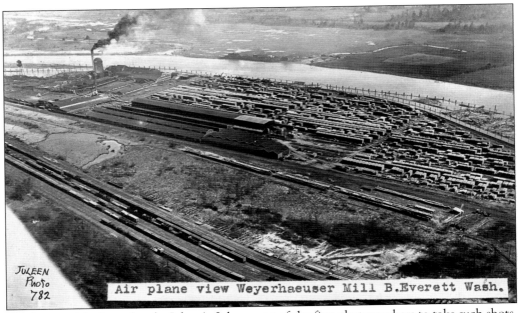

Here's an aerial view taken by John A. Juleen, one of the first photographers to take such shots. In 1915, Weyerhaeuser's Mill B was able to produce lumber so fast that prices dropped due to a glut on the market. Lower prices meant lower wages.

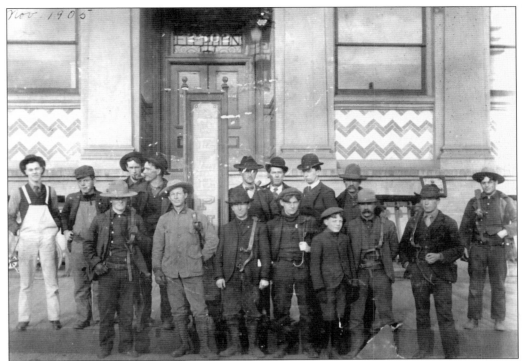

Unions were not limited to the mills. One of the oldest unions in Everett is the International Brotherhood of Electrical Workers or IBEW. This is a 1905 portrait of Local No. 191. In the front row at the left is R. Jay Olinger, president of the trade unions at the time of the Everett Massacre. Several members of the Olinger family were active in unions.

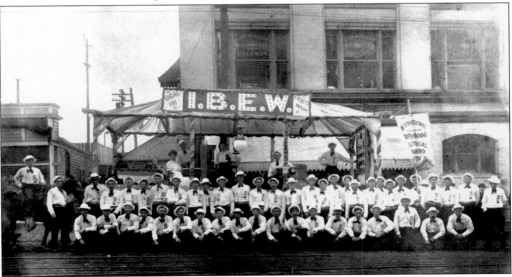

In 1912, the IBEW pose for a portrait in front of their float on Labor Day. This was the year that labor and industrialists really started going head to head in the political arena. The new charter called for a city election. IBEW's Jay Olinger was a candidate. Despite his popularity, Olinger was not returned and the new commissioners of Everett were all hardened businessmen.

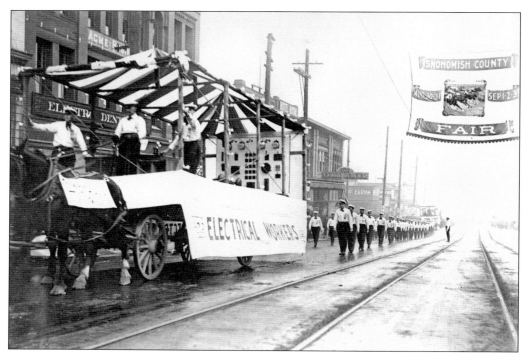

Jay Olinger stands at the far left on the front of the float. As more businessmen and industrialists gained control in Everett, more workers sought a firm foothold. The Industrial Workers of the World (IWW), frequently referred to as the Wobblies, had a radical socialist agenda that began to appeal to a growing number of workers.

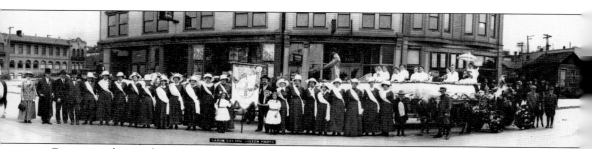

Concerns about jobs, wages, and security didn't just affect men. Women were also organized. Here the Women's Label League pose for a photograph. Women worked as long and as hard as men, but for less pay. While in the state legislature, former Everett mayor and mill owner Roland Hartley voted against an eight-hour workday for women.

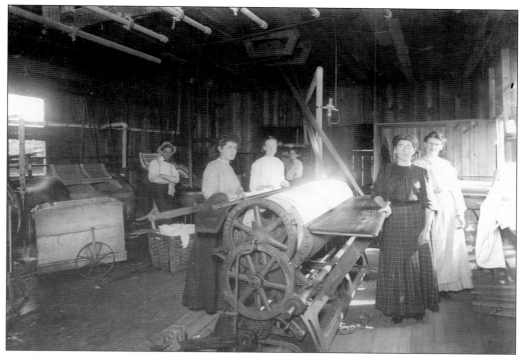

Laundry owners frequently fired women they suspected of having joined a union. In 1915, there was an attempt by the Laundry Owners Association to make laundry workers exempt from the new eight-hour-workday law. Many owners used apprenticeship loopholes to pay workers less than minimum wage. Of all the female dominated trades, laundry workers had the worst working conditions.

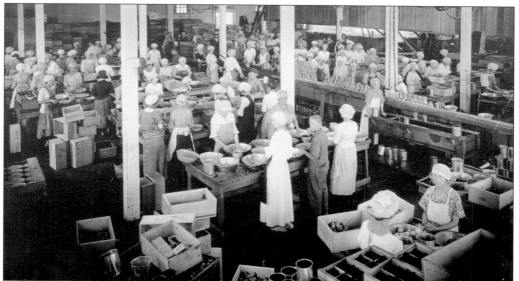

Workers at the Everett Fruit Products Company would have had a hot, sticky job as well. The company manufactured canned fruits and vegetables, jams, jelly, and vinegar. Women of all ages are visible in this portrait, including some quite elderly ladies.

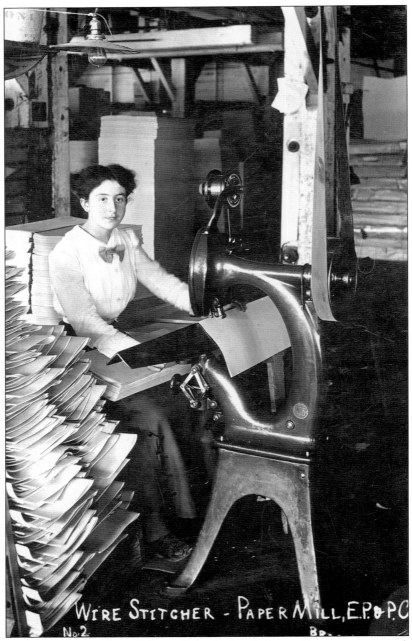

WIRE STITCHER - PAPER MILL, E.P.&P.C
No. 2 Br.

The paper industry was another offshoot of the timber industry. Here a woman worker stitches together "wires" for the Everett Pulp and Paper Company, located in the Lowell district. Wires were the screen-like surfaces that the wet paper slurry was spread upon to create sheets. The slurry was pressed thin over the wire's surface. The water dripped through the wire leaving a wet paper sheet behind. The paper was then dried, usually with the aid of drier felts, before being cut and sold. The Everett Pulp and Paper Company had many women workers who stitched wires, operated paper cutters, and more. William Howarth was president of the company when this picture was taken in 1915.

Even the theatre was organized in Everett. By 1916, there would be eight theaters—three were live performance venues with the remainder as movie houses. The Stage Employees Union consisted of workers from both types of business. Pictured here in 1911, the Stage Employees Union Local No, 180, from left to right, are (first row) Alva Stewart, Ira Brown, Art Pettersen, Ralph Tucker, and Mark Bebeau; (second row) Goldie Goldthorpe, Archie LaFreniere, Ole "Harry" Olson, Swede Forslund, and Art Tosland.

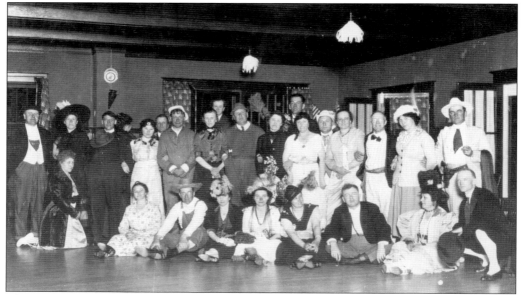

This c. 1915 photograph shows a costume party held at the Everett Golf and Country Club. Established in 1910, it remains one of Everett's premiere private clubs. While the ladies and gentlemen of the club socialized, the unions of Everett grew more socialist. It was clearly turning into a class struggle. Clough, Hartley, Jamison, and members of the Commercial Club decided the dissenters need to be silenced.

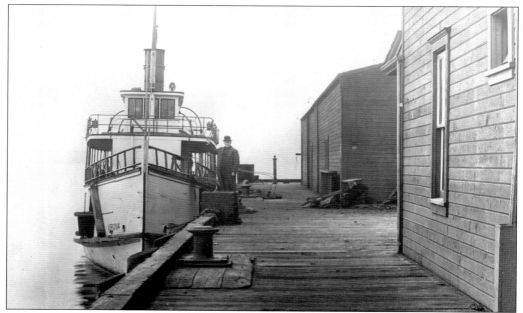

Trouble came to a head when, in 1916, Sheriff Donald McRae (supported by the Commercial Club) illegally attempted to block IWW members from speaking in Everett. Local labor leaders tried to protest and were similarly silenced. But Americans never take kindly to having their freedom of speech removed. On November 5, 1916, two steamers came from Seattle bearing more members of the IWW. One of the ships was the *Verona*, pictured here.

Sheriff McRae was not above taking the law into his own hands or using strong arm tactics to subdue those he considered ruffians. He is seen here in a newspaper clipping of the period. McRae, some regular deputies, and many newly deputized members of the Commercial Club met the *Verona* as the steamer edged up to the Everett dock. They were determined not to let the Wobblies land.

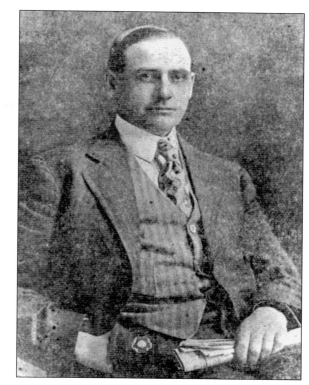

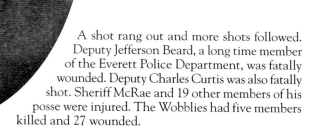

A shot rang out and more shots followed. Deputy Jefferson Beard, a long time member of the Everett Police Department, was fatally wounded. Deputy Charles Curtis was also fatally shot. Sheriff McRae and 19 other members of his posse were injured. The Wobblies had five members killed and 27 wounded.

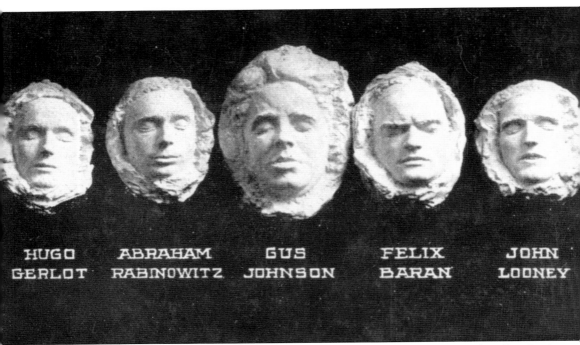

HUGO GERLOT · ABRAHAM RABINOWITZ · GUS JOHNSON · FELIX BARAN · JOHN LOONEY

Seventy-four IWW members were arrested after the massacre and ended up in Sheriff McRae's jail. The bodies were collected and autopsies were performed for the court. Norman H. Clark, in his book *Milltown*, points out that the three physicians who performed autopsies on the victims all belonged to the partisan Commercial Club and two had been participants with Sheriff McRae at the massacre. Within a month of the event, the IWW had released this postcard featuring the death masks of the IWW victims. They had released other materials as well. They advertised loudly that these workers had been killed in an attempt to exercise their freedom of speech. Tensions over the confrontation continued as did the shingle workers strike. The citizen deputies from the Commercial Club retained their badges and the IWW members made a point of being difficult prisoners. The National Guard had to be sent in to calm things down.

A memorial poster by M. Pass soon appeared in the *Industrial Worker* newspaper to honor the fallen IWW members. Felix Baran, Hugo Gerlot, Gus Johnson, John Looney, and Abraham Rabinowitz were now martyrs for their movement. Note that the death masks have been reproduced at the top of the poster.

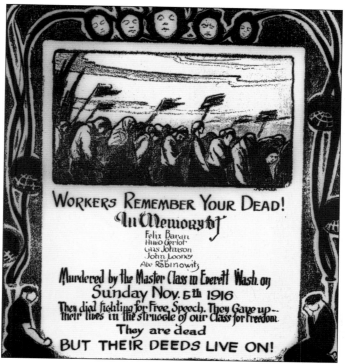

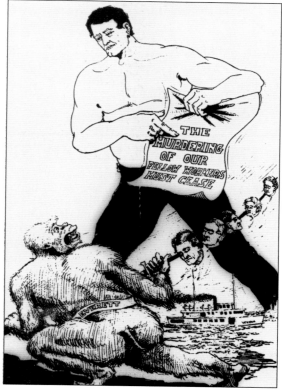

An artist named Chumley soon followed up the poster with a political cartoon. Everett is characterized as a big ape. The five dead workers are again displayed, this time skewered by the capitalist ape, while the steamer *Verona* chugs away in the background. This cartoon also appeared in the *Industrial Worker* newspaper.

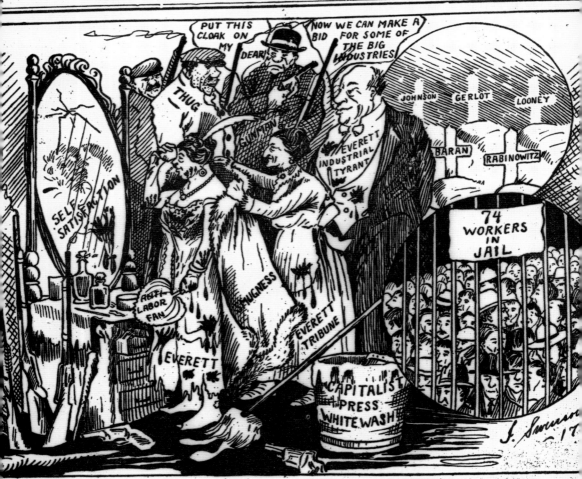

'PRIMP AND PRIME IT CAN'T EFFACE THE BLOODY STAI

Artist J. Swenson outdid himself with details in this cartoon of the massacre. Everett is seen as a dirty, bloodied woman. She holds an antilabor fan while the *Everett Tribune* cloaks her in "smugness." Smoking weapons lie all around as she looks into the mirror of self satisfaction. Behind her are Everett's Industrial Tyrant and his strike-breaking thugs and standing in readiness is a barrel of whitewash from the capitalists. Outside in the cold are the graves of the five IWW martyrs and 74 workers wait in jail. While it is doubtful that the IWW's political cartoons influenced anyone, eventually all of the members were released from jail except one. The one, Thomas Tracy, was later acquitted in court. There was simply no way to prove who had fired the first shot. Further, several wounded deputies had been shot in the back, but whether it was while they were attempting to leave the dock or from the trigger-happy, newly deputized businessmen standing behind them, no one could say.

Five

AFTER THE MASSACRE

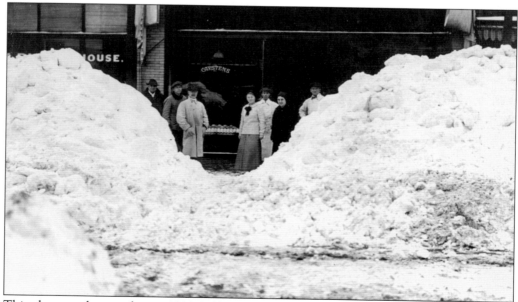

This photograph was taken at 2820 Colby Avenue in February 1916, a key year in Everett. The first part of the year brought a huge snow that closed the downtown. The latter part of the year brought riots and bloodshed. A war in Europe was escalating, and people began to wonder if America was going to get involved.

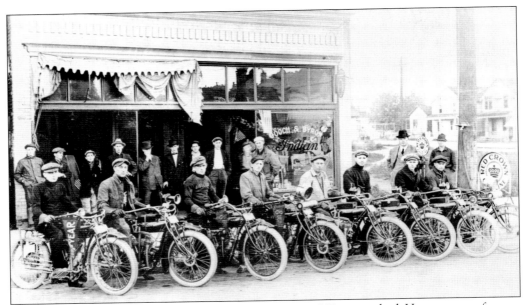

For the youth of Everett, there was little to cheer them as 1917 approached. Here a group of young men pose on motorcycles before the Gooch and Byron dealership. Would they go into the mills where wages remained low despite the protests or would they end up becoming soldiers in a land far away where an archduke's murder had escalated into a war of unbelievable proportions?

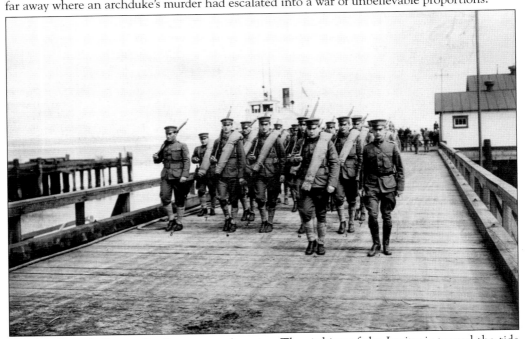

The war to end all wars finally came to America. The sinking of the *Lusitania* turned the tide of public opinion. On April 6, 1917, President Wilson declared war on Germany. Here the men of Everett head to camp. Notes on the back of this photograph identify the soldiers as Captain Goldman, Sergeant Stanton, Corporal Joyce, Sergeant Ritchie, Sergeant Bolder, and Privates Hosstad, Johnson, Boyle, Hyde, and Stoddard.

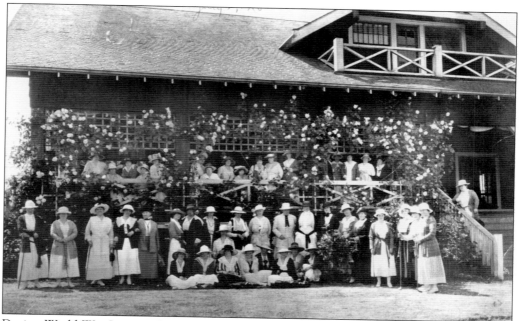

During World War I, many things in Everett stayed the same. The Everett Country Club still hummed with activity. Worried for their absent husbands and sons, women worked at the Red Cross or for other war relief efforts. They heeded government warnings not to waste food and some tried their hand at a victory garden. This photograph was taken on July 2, 1918.

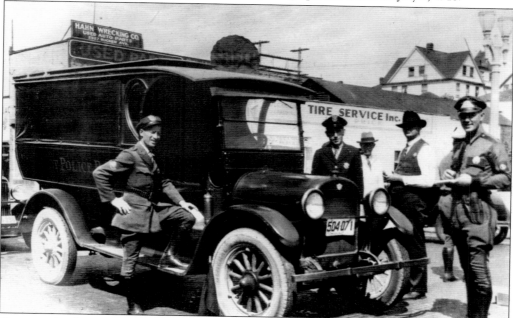

On returning home, most men took the same job they had before they left. There was a demand for timber now, and the mills ran full tilt. The Commercial Club had disappeared and the newer, friendlier chamber of commerce had taken its place. Even the police force of 1920s Everett had a new look.

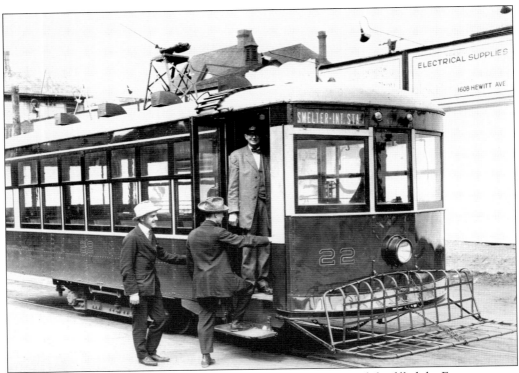

The streetcars changed during the war years. As more private automobiles filled the Everett streets, a more compact, front-entrance jitney, or burney car, was introduced. Driver Tom Minton welcomes transportation superintendent Henry Grant and a passenger aboard a car at the Interurban Depot. The exact year is unknown.

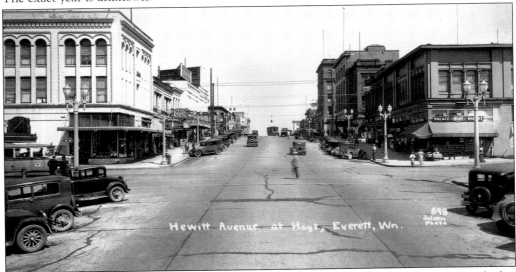

The intersection of Hewitt and Hoyt Avenues demonstrates the changes that occurred after World War I. Private automobiles are filling the streets and the parking spaces of downtown are full. Sidewalks are busy with shoppers. For Everett, the postwar economy was going well. The demand for timber kept the mills busy and the workers working, for a time anyway.

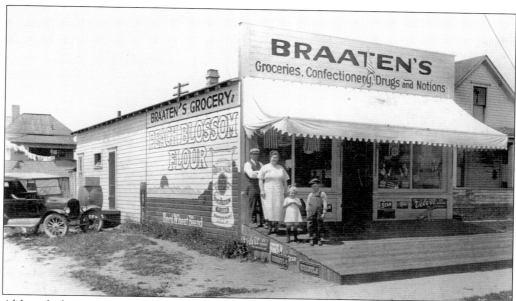

Although the government had urged "meatless and wheatless" days during World War I, little had changed in the way of the postwar grocery store. Braaten's Groceries stood on Broadway Avenue. It appears that the family lived behind the shop. This photograph was taken in the early 1920s.

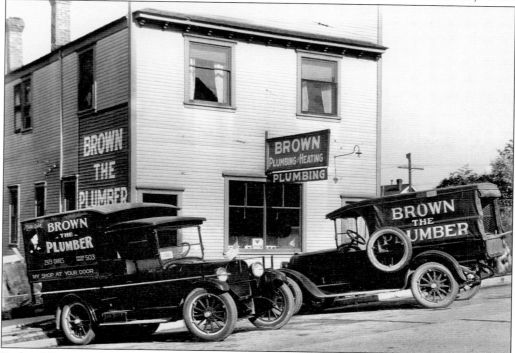

Richard Brown of Brown Plumbing and Heating lived over his shop at 2923 Oakes Avenue. Cars had replaced wagons. Soon after this 1925 photograph was taken, colored sinks, toilets, and tubs would be widely available on the market rather than the standard white enameled and pottery fixtures.

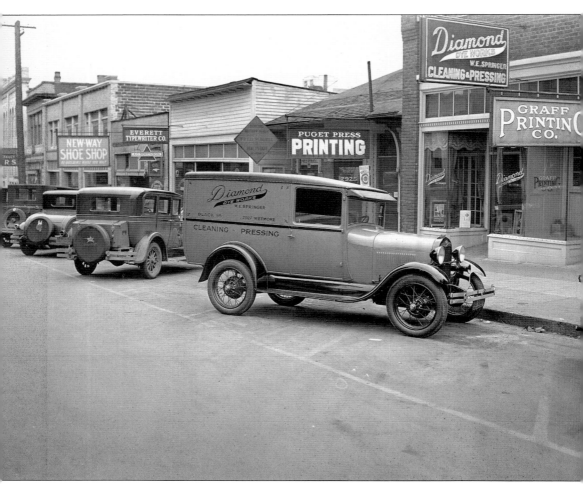

Several shops are visible in this October 1928 photograph of Wetmore Avenue. W. E. Springer's Diamond Dye Works advertises "Something Needs Cleaning Now!" in their window. Springer also displays his new delivery truck. The Graff Printing Company and Puget Press Printing flank the Dye Works. Further up the street are Fred Buell's Real Estate, the Everett Typewriter Company, New-Way Shoe Shop, and Adam Skucy Furs. On the surface, the economy was going well. Consumerism had reached an all-time high and the stock market was booming. Unfortunately the stock market was booming on borrowed money and, consequently, on borrowed time. A crisis of confidence was coming in the business and financial world. One year after this picture was taken the stock market crashed. With it went the fortunes and life savings of many people. Many businesses would crumble. It would be another hard time for Everett, but by now the city knew how to live through hard times.

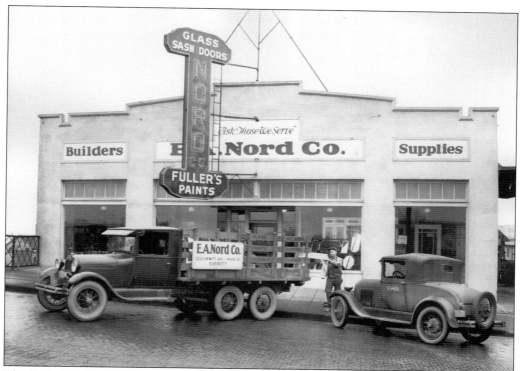

The E. A. Nord Company operated at 2202 Hewitt Avenue. This photograph was taken in the year of the stock market crash. Nord supplied building materials such as lumber, roofing, doors, windows, mill work, fixtures, glass, and paint.

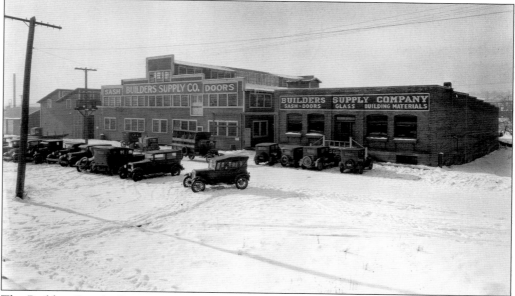

The Builders Supply Company was a larger establishment than the E. A. Nord Company, but carried similar items. It was located at 2925 Wetmore Avenue. The company president was George A. Brown.

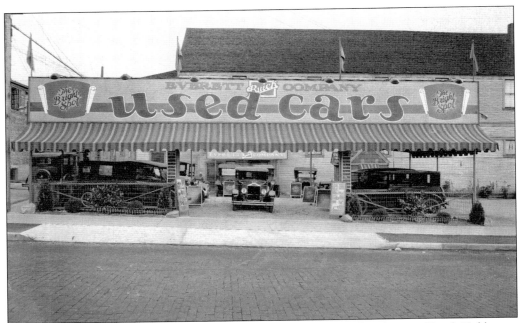

The Everett Buick Company's used car lot was located at 3001 Rucker Avenue. Frank Hobbs was the company president. Advertised as "The Bright Spot," many cars probably found their way to this and other used car lots as the Great Depression hit Everett and families found themselves strapped for cash.

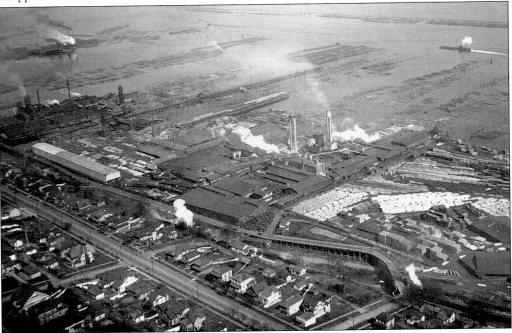

The extent of the waterfront development is illustrated in this 1928 aerial photograph from Juleen Studios. The mills are running at the moment, but the Great Depression would soon shut many of them down. It was the last hum of activity before the close of the decade.

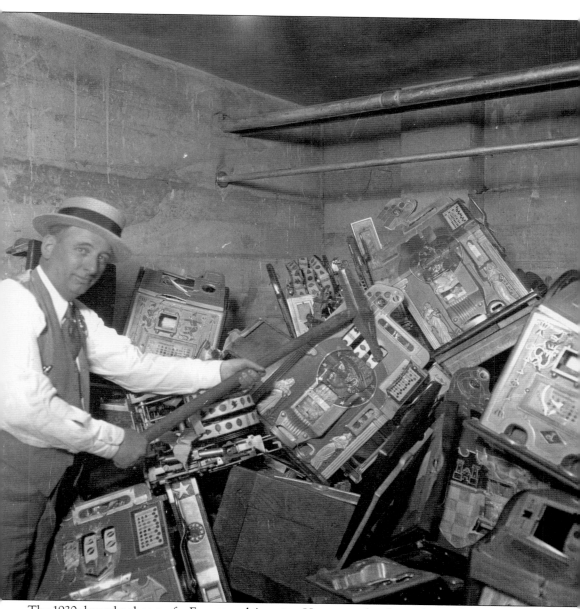

The 1930s brought changes for Everett and America. Here a man breaks up slot machines captured in a raid at a local speakeasy. By this time, it was clear that Prohibition was a gigantic failure. Not only did it not stop people drinking, it benefited organized crime. Gangsters made huge amounts of money from supplying the public with what they wanted. Illegally made bathtub gin or hooch literally blinded or killed many people. The Everett Police Department was kept busy tracking down moonshine stills and breaking them up. But the stills were simply rebuilt. It was too lucrative not to rebuild. The Great Depression was not over in 90 days as President Hoover had promised. People wanted their amusements back to get them through the troubled times. In 1933, Prohibition was repealed. Franklin D. Roosevelt was elected president. He brought in his New Deal of reform that created jobs and Social Security. It wouldn't solve problems overnight, but it was a step in the direction of recovery.

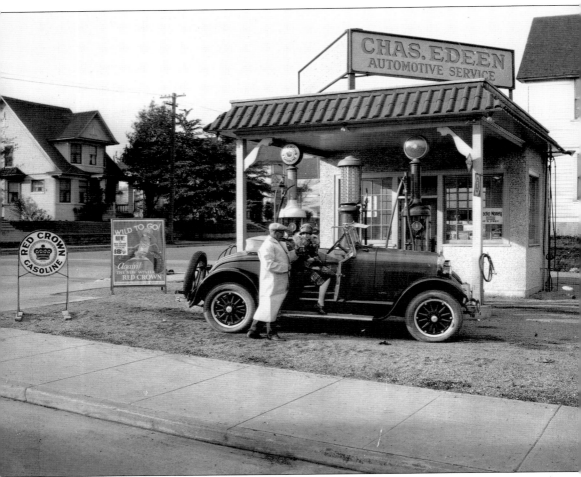

Edeen Automotive Service at the corner of Rockefeller and Everett Avenues advertises Standard Oil's new Winter Red Crown gas at 18.5¢ a gallon. Standard Oil was, of course, a Rockefeller family company. Rockefeller left many reminders of himself in Everett even though he never bothered to visit. Auto production in the United States was cut nearly in half by the Great Depression. Many smaller car companies didn't survive, but the big three—Ford, Chrysler, and General Motors—did. With fewer people buying cars, the once thriving market in tires and other auto related goods slumped. Wages and jobs were cut. This didn't stop Americans from buying cars, however. The love affair between people and their vehicles would remain.

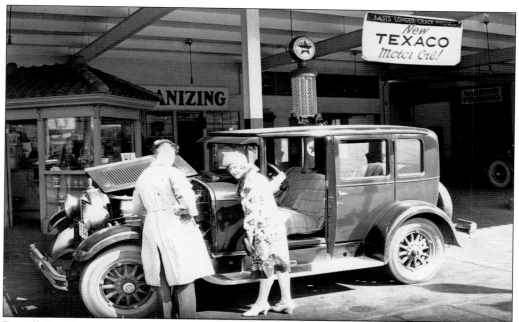

Russell Ormsby was manager of the Everett Super Service Station, located on the southeast corner of Hewitt and Rucker Avenues. They offered a full line of Texaco products. The gasoline in this pump is the brand new Texaco Ethyl gasoline, which came out in 1930 when the photograph was taken. Ethyl gasoline was later renamed Fire Chief gasoline.

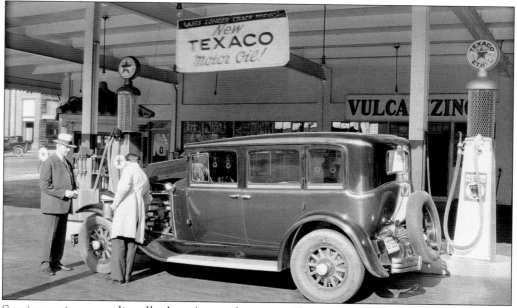

Service stations were literally that. An employee actually pumped the gas for you. The gasoline had to be hand pumped into the high reservoir then allowed to flow into the car's tank by gravity. Besides selling gas, they also offered assistance such as checking fluid levels and oil changes. The sign in the background also offers vulcanizing, which was the general term used for repairing or retreading tires.

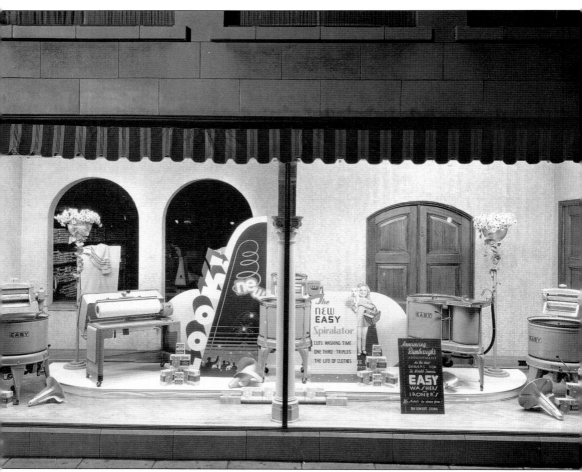

The Rumbaugh-MacLain department store was located at 2804 Wetmore Avenue. It would later become The Bon Marche and then an office building. Washing machines were electric by this time and their use was widespread. The Easy brand washing machine, seen in this J. A. Juleen Studios photograph taken June 22, 1935, wasn't always easy. If not properly grounded, and in many households they were not, they frequently gave electrical shocks. The advertisement for the new Easy Spiralator claimed it cut washing time by a third and tripled the life of clothes. Maytag had invented the agitator, but the Easy Company modified it. Easy also had the honor of producing the first wringer-less washing machine. It would be several years before other companies caught on and made wringer-less machines the industry standard. Also in the photograph are stacks of White King Soap. Then, as now, washing machines came with free soap samples.

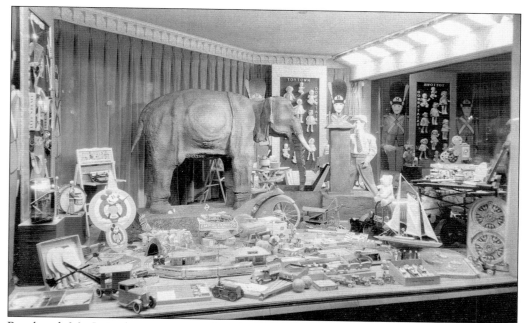

Rumbaugh-MacLain department store's toyland window for the 1934 Christmas season turned many a child's head. The elephant must have seemed gigantic. Tricycles, kiddie cars, and dolls galore are liberally dotted with Mickey Mouse themed items. Mickey Mouse was at the height of his popularity during this period. To the middle right of the window, there is even an early Mickey Mouse movie projector.

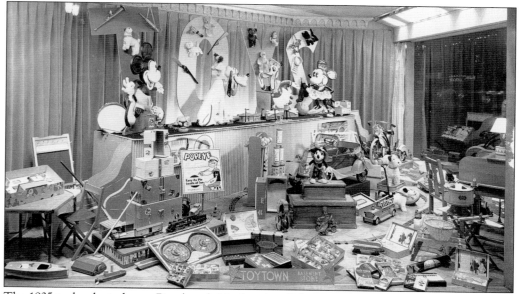

The 1935 toyland window at Rumbaugh-MacLain's still features a lot of Mickey Mouse toys along with other Disney-themed items. There's also a Popeye Paintograph kit and a Tom Mix game to add to the movie or cartoon inspired playthings. The same kiddie cars, tricycles, and electric trains have reappeared. Judging by this display, stuffed animal toys were more in demand than dolls this season.

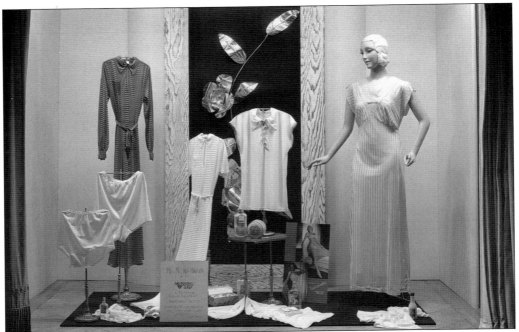

A 1938 window at Rumbaugh-MacLain's features a line of ladies' lingerie called Dainty Underlovlies by Munsing Wear. A notice board announces that a Miss Monte Hargus, stylist for Munsing Wear, will be in the second floor lingerie department on October 20 to advise ladies regarding Dainty Underlovlies problems. The soaps and bath powders in this picture are a Yardley brand.

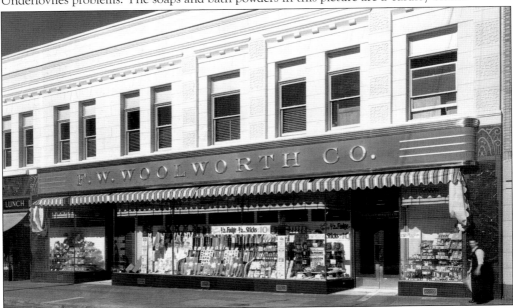

Not everyone could afford to shop at pricey department stores like Rumbaugh-MacLain. In 1939, F. W. Woolworth's opened a store at 2824 Colby Avenue. The manager was Mr. Paul J. Rice. The Woolworth's chain was popular with average American families who didn't have a lot to spend. This was especially the case in a post-Depression mill town like Everett.

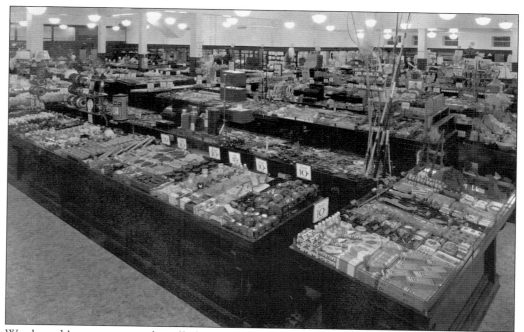

Woolworth's was commonly called a five and dime, or a dime store, because much of their merchandise sold at a fixed priced of 5¢ or 10¢. This photograph shows the vast array of counters, mostly bearing 10¢ signs. Woolworth's was unique in that it was partially self-service. The customers could browse and select the merchandise themselves rather than having a shop assistant retrieve items from behind a counter.

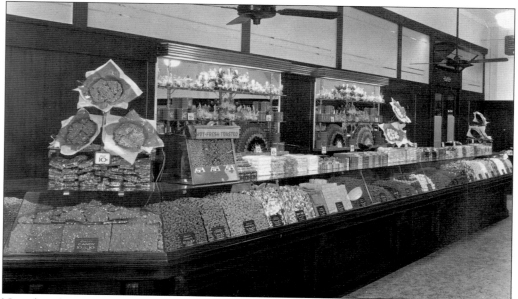

Nostalgia doesn't get any better than the Woolworth's candy counter. The scent of chocolate and hot nuts wafted across the store, drawing children and adults alike. Candy, dispensed in dime portions, was stacked in tempting ziggurats against the glass of the display case. Large slabs of peanut brittle lie along side anise wafers, chicken bones candy, dollar mints, bridge mix, and more.

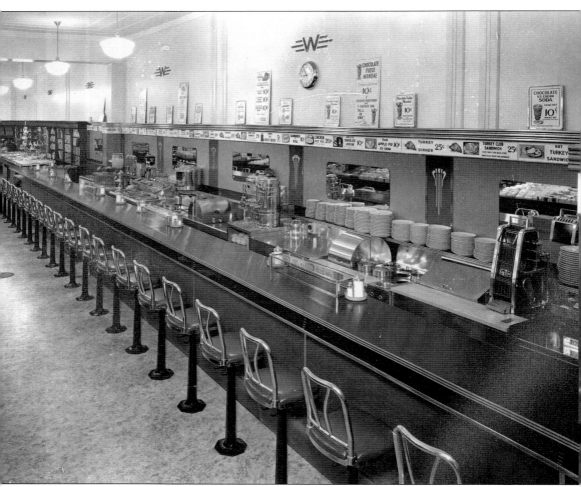

The Woolworth's in Everett also featured a lunch counter. Here shoppers could take a break to enjoy a turkey dinner for 25¢ or a hamburger or piece of apple pie for a dime. The food was fairly priced and convenient. In 1993, a Woolworth's lunch counter was enshrined in the Smithsonian Museum, not because of the food, but because the Woolworth's lunch counter in Greensboro, North Carolina, was the site of a significant civil rights sit-in during the 1960s. This wasn't the chain's only controversy. From the beginning, it was often criticized for undercutting competitors and forcing small local businesses to close. In later years, Woolworth's spun off a new chain of discount stores called Woolco. In 1994, the last of the Woolco stores were bought out by Walmart. Walmart, of course, draws the same criticism now as Woolworth's did in its heyday.

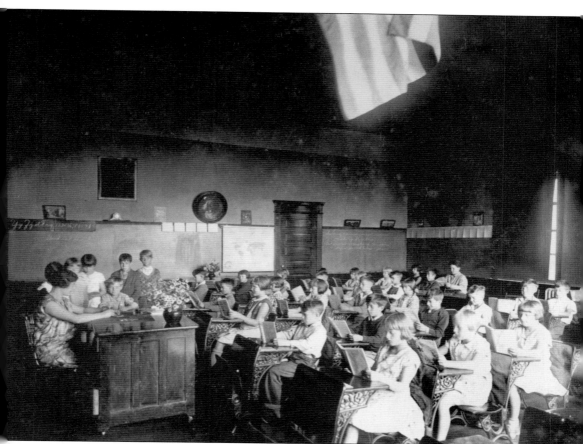

The 1930s were hard for schools. Unlike some places in the nation, Everett schools provided children with textbooks, but the basic items were in short supply. This photograph shows Miss Jacob's rooms, 4A and 4B, at the Jackson School on the corner of Thirty-seventh Street and Norton Avenue. It was September 1930, the first full school year after the stock market crash. No doubt many of her students' families were already feeling the pinch. Good food and proper clothes would have been a concern. No spare cash would have been available for school supplies or clothes. Miss Jacobs herself may have been worried about job security. With less revenue coming in, districts had to budget carefully. Oddly enough, the concept of progressive education was much discussed at this lean time. It is interesting to note that the classic Dick and Jane reading textbooks came into being the year after this photograph was taken.

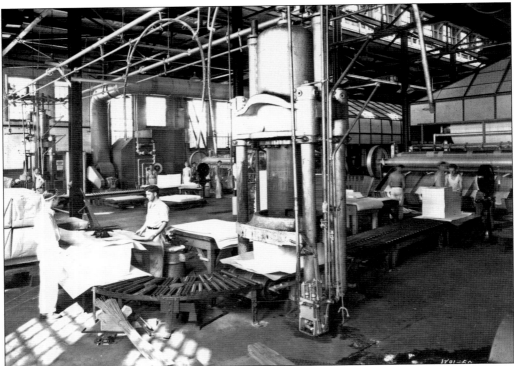

The age of the timber baron was gone from Everett. The Depression shut down most of the lumber mills. One related industry that stayed strong was paper production. This 1934 photograph shows rayon pulp being baled at the Puget Sound Pulp and Timber Company. The demand for newsprint, packing materials, and other grades of paper skyrocketed when World War II hit Europe, and continued strong until late into the 20th century.

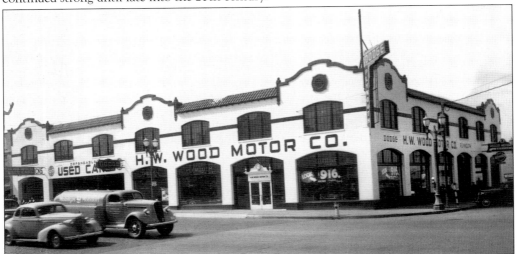

It's likely that H. W. Wood Motor Company at the corner of Hewitt and Rucker Avenues was seeing an increase in sales at the time of this 1940 photograph. The economy was picking up as World War II boosted U.S. industries. The building seen here had formerly housed J. O. Fisher Motor Company in the 1930s. At the time of this writing, the building has become a health club.

Six

THEN AND NOW

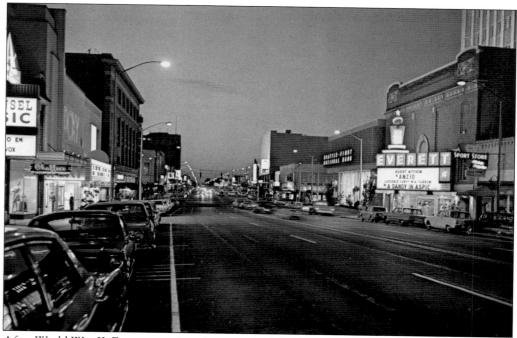

After World War II, Everett continued to grow and change. A new industry was coming. Boeing and the age of aerospace would change the face of Everett forever. This photograph shows Colby Avenue in 1968, the same year that Boeing rolled out its 747 and opened the factory doors for tours. From that moment on, Everett ceased to be a mill town and became instead a city of industry.

In late 1966, work began on Boeing's Everett plant, and the first employees arrived in 1967. No longer would the streets of Hewitt, Colby, and Rucker be the city's center of attention. The focus shifted south to the Boeing and Paine Field. In this 2005 photograph, Boeing machinists strike just as their lumber mill counterparts did a century before. Boeing is now the largest employer in Snohomish County.

In 1987, construction on Naval Station Everett began. In 1994, operations officially started. The Navy station is home to a destroyer, three frigates, a nuclear-powered aircraft carrier, and a Coast Guard buoy tender. There are 450 sailors and civilians working at the station. Since the advent of the navy, Everett has now gained "navy town" as an additional title.

There are many changes in Port Gardner Bay since Captain Vancouver first fired his cannons. This photograph was taken from Providence Hospital's Pacific campus, the site of the first Monte Cristo Hotel. Looking out over the bay, the early mills are gone, replaced by the navy and Kimberly-Clark. There currently are plans in the works to reclaim and renovate the waterfront area.

Perhaps one of the most impressive projects recently undertaken by the City of Everett is Everett Station. The building houses a giant transportation hub that includes commuter rail service between Everett and Seattle. Community Transit, Everett Transit, and Sound Transit buses are all connected here. Private bus carriers such as Greyhound also come into the station. There is a large park and ride lot to encourage carpooling. A small cafe serves soup and sandwiches to hungry commuters. Everett Station is also home to Worksource, the new name and new look for the old unemployment office. Worksource not only offers employment search tools, but also career training, counseling, and other social services. The University Center of North Puget Sound has further education options here as well. The building is decorated with art celebrating the early days of Everett—a fine tribute to the city.

It's doubtful that Henry Hewitt ever dreamed that a hockey team would play on the street that bears his name. But that is exactly what happened. Hockey, arena football, big name concerts, trade shows, wedding shows, and more happen at the new Everett Events Center on Hewitt Avenue. The Center is visible in the middle of this photograph taken from below Broadway looking west on Hewitt Avenue.

The Everett AquaSox is a class-A farm team for the Seattle Mariners. Many Mariner greats, including such legends as "Big Unit" Randy Johnson and Jay "Bone" Buhner, did rehab with the AquaSox as they were coming back from injuries. Rumor has it that Johnson asked if he could keep his AquaSox uniform as a memento. Buhner wowed the Everett crowds by hitting several home runs out of the stadium.

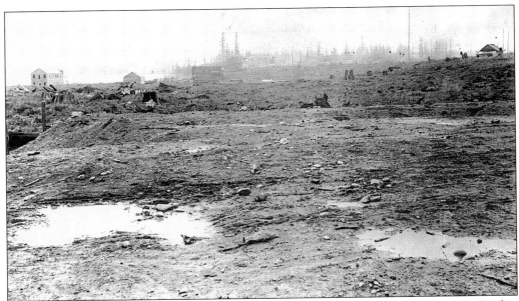

This spot, photographed in early 1892 by King and Baskerville Studios, later became Rucker Avenue, near Pacific Avenue, looking north.

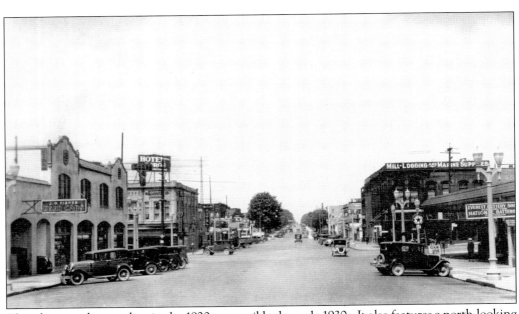

This photograph was taken in the 1920s or possibly the early 1930s. It also features a north-looking view of Rucker Avenue.

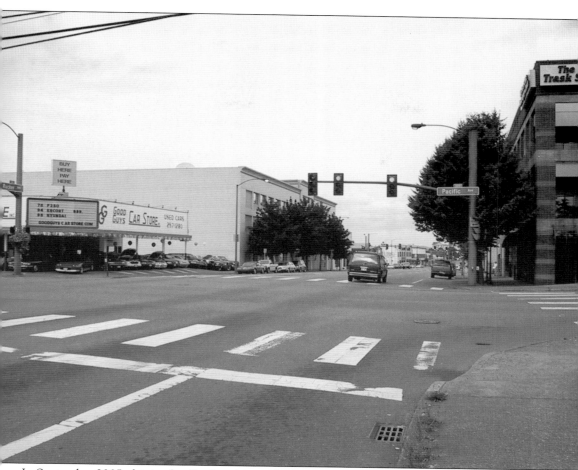

In September 2005, this is what Rucker Avenue looked like. As in the previous two photographs, the view faces north from the southeast corner of Rucker and Pacific Avenues, where the Everett Super Service Station once stood. In 2001, the Trask Surgical Center at the right side of the photograph opened (as a remodel). The large white building on the left side is the Snohomish Health District Building. This office houses the County Board of Health, the Environmental Health Division, Disease Control, Community Health, and Statistics. In the distance, one can just make out the building that once housed the H. W. Wood and J. O. Fisher Motor Companies.

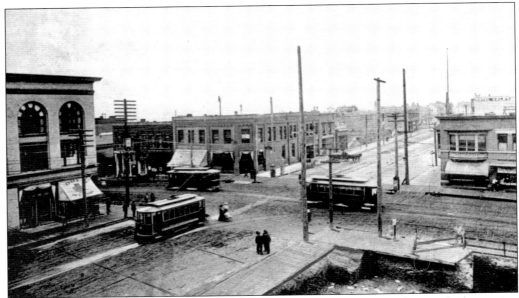

This photograph of the intersection of Colby and Hewitt Avenues was taken at the beginning of the 20th century by Kirk and Seely Studios.

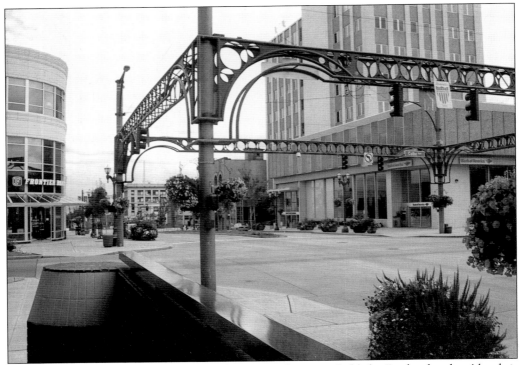

This is the same intersection in 2005. The corner that once held the Rucker brothers' bank is still a bank. Buses have replaced the streetcars.

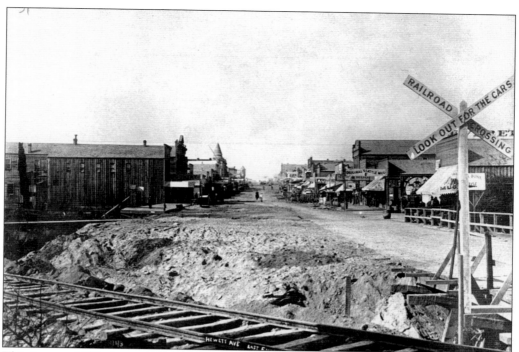

This January 1892 photograph from the Frank LaRoche collection shows Hewitt Avenue. This view faces west near Swalwell's Wharf.

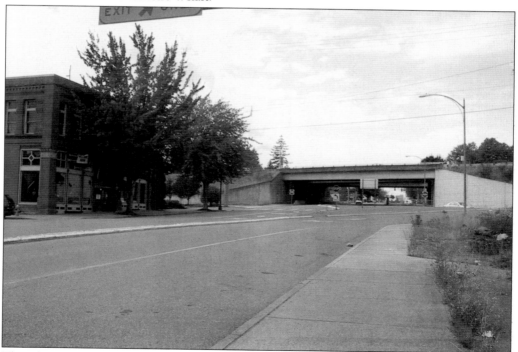

This photograph was taken from a similar location over 100 years later. Interstate 5 now cuts through the old district that was once considered the wildest in town.

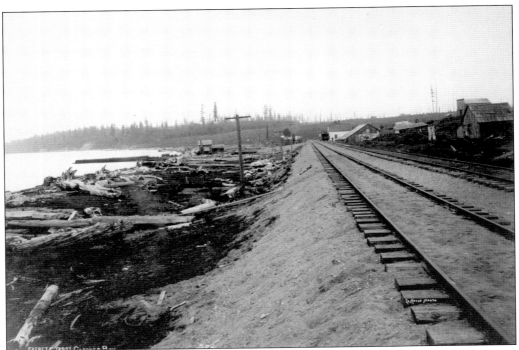

The Seattle-Montana Railroad bordered Port Gardner Bay before the Great Northern came to town. This October 1891 photograph looks north from the site of the old Puget Sound Wire Nail and Steel Company.

Here's a similar perspective from 2005. The large, wooden structure behind the Marina Village sign is the old Weyerhaeuser office building. It was built in 1923 and, as one might expect from a lumber company such as Weyerhaeuser, features a number of fine woods. It now belongs to the Everett Chamber of Commerce.

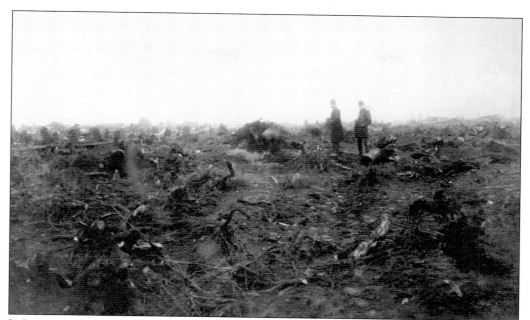

In January 1892, two early developers survey their new domain. This photograph by Frank LaRoche looks west from what will one day be the intersection of Pacific Avenue and Maple Street.

Here is the same view of Pacific Avenue in 2005. Behind the camera is the freeway. Small businesses and restaurants such as Denny's and Hunan Palace dot the hill as it climbs over distant railroad tracks. The Everett Station cannot be seen but is hidden far ahead to the left. Out of frame to the immediate right is Group Health Cooperative's Everett Medical Center.

Lastly and most importantly is the Everett Public Library, located at 2702 Hoyt Avenue. The library building dates back to 1934, although it has been gently remodeled and expanded. The most spectacular thing about the library is the Northwest Room, dedicated to preserving the history of the city of Everett and the region. Overseeing the collection of books, photographs, and audio tapes are two dedicated historians, Margaret Riddle and David Dilgard. Without their help, this book and others like it would not be possible. They work daily to preserve the materials donated to the library, making digital scans of fading photographs so that they may be preserved and enjoyed forever. Many of these are available online. If you've enjoyed this book, you'll enjoy visiting the Everett Public Library's Northwest Room at www.epls.org/nw/.